Belfountain and Inglewood Ontario in Colour Photos, Saving Our History One Photo at a Time

Photography
by Barbara Raué
©2019

Series Name: Cruising Ontario

Book 234: Belfountain, Inglewood

Cover photo: 15612 McLaughlin Road, Inglewood, Page 51

©All the photos in this book have been taken with my cameras. I own the rights to them.

Series Name: Cruising Ontario
Saving Our History One Photo at a Time
in colour photos

Books Available in Alphabetical Order:
Aberfoyle, Acton, Ajax, Alton, Amherstburg, Ancaster, Arthur, Auburn, Aylmer, Ayr, Beaver Valley, Belgrave, Belleville, Bloomingdale, Blyth, Brantford, Brockville, Burford, Burlington, Caledon, Caledonia, Cambridge, Carlow, Chatsworth, Clifford, Collingwood, Conestogo, Delhi, Dorchester to Aylmer, Drayton, Drumbo, Dundas, Dunlop, Eden Mills, Elmira, Elora, Erin, Essex, Fergus, Goderich, Grimsby, Guelph, Hagersville, Hamilton, Hanover, Harriston, Hespeler, Jarvis, Kingston, Kingsville, Kitchener, Lake Superior, Lincoln, Linwood, Listowel, London, Lucknow, Merrickville, Mono, Mount Forest, Mount Pleasant, Neustadt, New Hamburg, Newboro, Newport, Niagara-on-the-Lake, Niagara Falls, North Bay, Oakville, Onondaga, Orangeville, Orillia, Oshawa, Owen Sound, Palmerston, Paris, Pelham, Perth, Peterborough, Petrolia, Pickering, Port Colborne, Port Elgin, Portland, Preston, Rockwood, Sarnia, Sault Ste. Marie, Seaforth, Sheffield, Shelburne, Simcoe, Smiths Falls, Smithville, Southampton, St. Catharines, St. George, St. Jacobs, St. Marys, St. Thomas, Stoney Creek, Stratford, Thamesford, Thunder Bay, Tillsonburg, Toronto, Waterdown, Waterford, Waterloo, Welland, Wellesley, West Flamborough, Westport, Whitby, Windsor, Wingham, Woodstock

Book 216: Sudbury
Book 217: Parry Sound
Book 218-219: Uxbridge
Book 220: Port Perry
Book 221-222: Stouffville
Book 223: Colborne

Book 224: Grafton, Bolton
Book 225-229: Cobourg
Book 230-233: Port Hope
Book 234: Belfountain, Inglewood

Table of Contents

Belfountain Page 5

Inglewood Page 41

 Caledon is a town in the Regional Municipality of Peel in the Greater Toronto Area. Caledon remains primarily rural. It consists of an amalgamation of a number of urban areas, villages, and hamlets; its major urban centre is Bolton on its eastern side adjacent to York Region.

 Caledon is one of three municipalities of Peel Region. The town is just northwest of the city of Brampton. In 1973 Caledon acquired more territory when Chinguacousy dissolved with most sections north of Mayfield Road (excluding Snelgrove) transferred to the township.

 Some of the smaller communities in the town include: Alton, Belfountain, Boston Mills, Caledon, Caledon Village, Campbell's Cross, Cheltenham, Inglewood, Mono Mills, Sandhill, Terra Cotta, and Victoria. The region is very sparsely populated with farms.

 By 1869, Belfountain was a picturesque village in the Township of Caledon County Peel on the Forks of the Credit Road on the Credit River. There were stagecoaches to Erin and Georgetown.

 After the survey of Caledon Township was completed in 1819, pioneers such as the Grahams, McColls, McCannells, Martins, Whites and McGregors settled in the area around present day Inglewood. They cleared the land, sharing common problems and interests.

In 1843, on the nearby Credit River, Thomas Corbett built a dam and dug a mill race to provide water power to run the Riverdale Woolen Mill. David Graham became a partner in the mill in 1860, and after a fire, reconstructed it in stone in 1871. By this time, Graham was Corbett's son-in-law. The mill attracted potential employees and their families to the area. Early settlers discovered deposits of sandstone and dolomite nearby on the Niagara Escarpment. Joachim Hagerman opened a quarry in 1875, the first of many.

The Hamilton & Northwestern Railway arrived in 1877 and was crossed over by the Credit Valley Railway in 1878. The railways provided cheap and easily accessible transportation, for both locally quarried stone and manufactured goods of the woolen mill. A general store and railway hotel were soon built.

The village housing built in this period, much of it by Graham, reflected the Ontario Cottage form popular in that Victorian era. Most houses were built using local lumber from the William Thompson Planing Mill, a more affordable option than brick. These cottages usually featured a front verandah, a center door symmetrically flanked by windows and a steep roof line with a front center gable surrounding a Gothic or arched window, the basic elements of the Victorian Gothic style. In Inglewood, most homes were left unadorned, a style referred to locally as Rural or Carpenter's Gothic.

The increase in population gave rise to many small industries, and from the mid-1880s until 1910, Inglewood's commercial growth included several general stores, a blacksmith, a livery and wagon maker's shop, a butcher shop, a bakery, a general hardware and tinsmith business, a barber shop, glove factory, post office, library, and a branch office of the Northern Crown Bank.

Belfountain

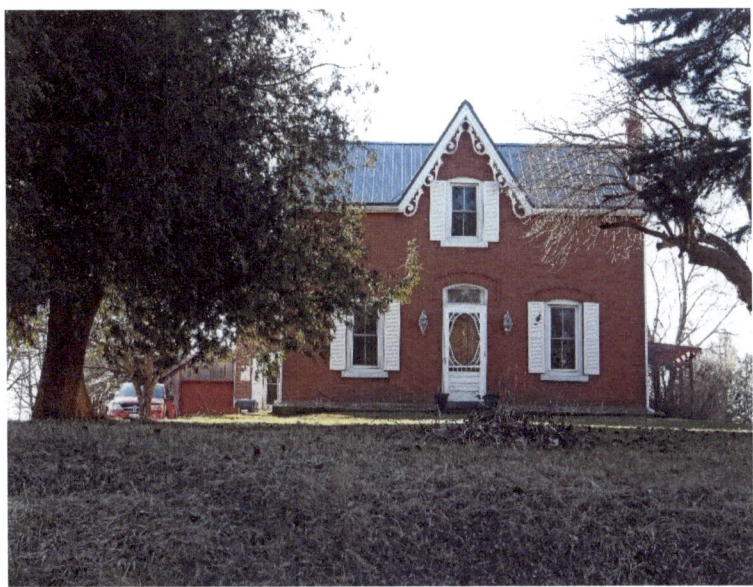

Gothic - verge board trim on gable

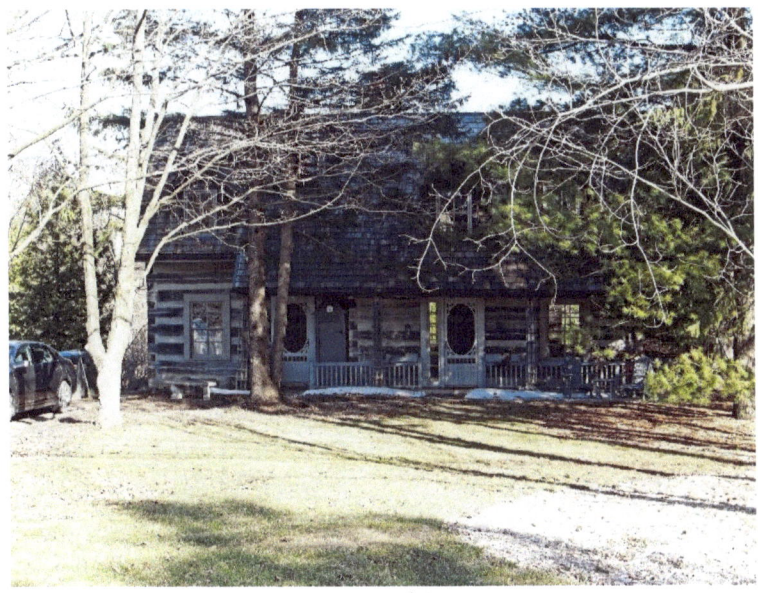

Log cabin

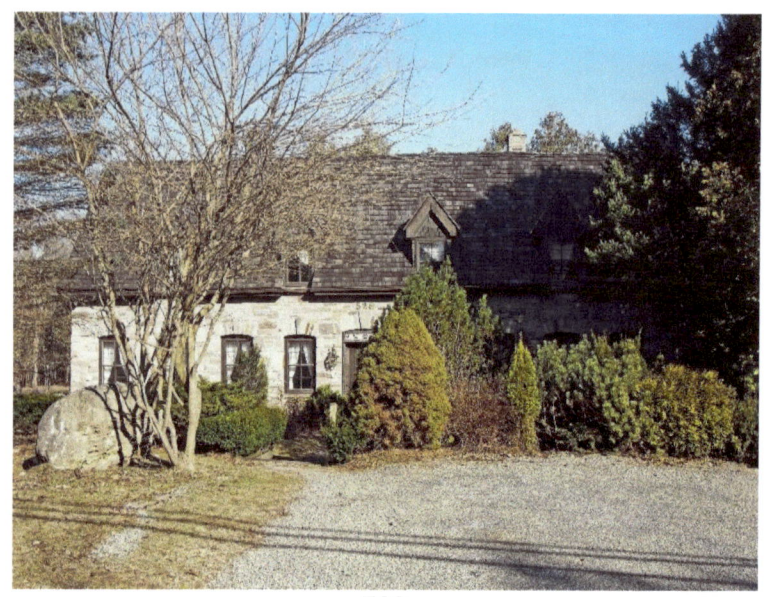

523

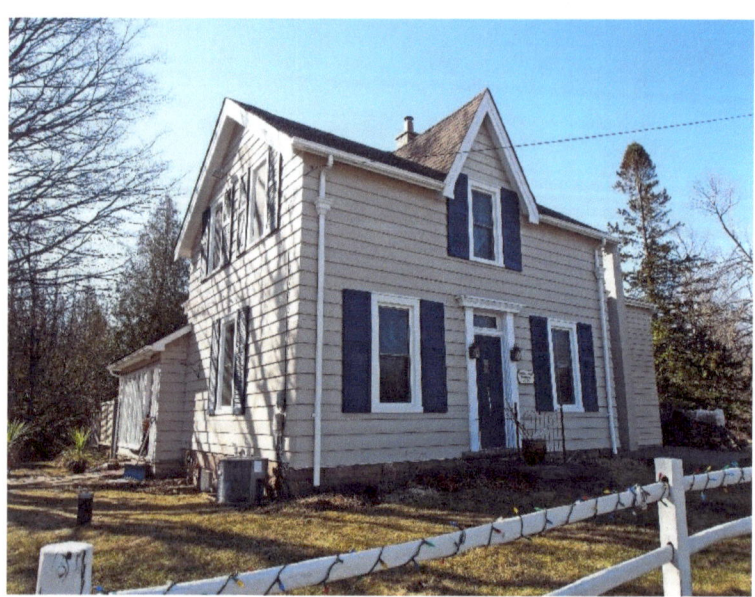

Gothic - Thomas J. Bush, Postmaster until 1861

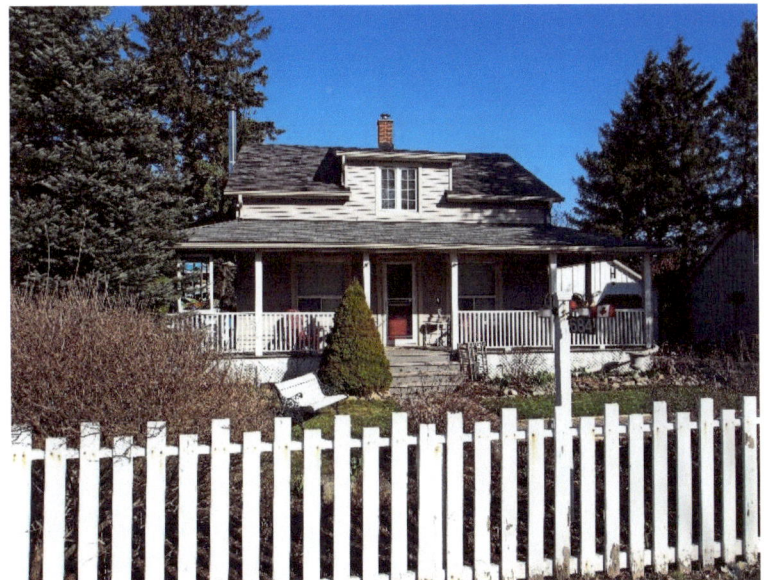

684 Bush Street

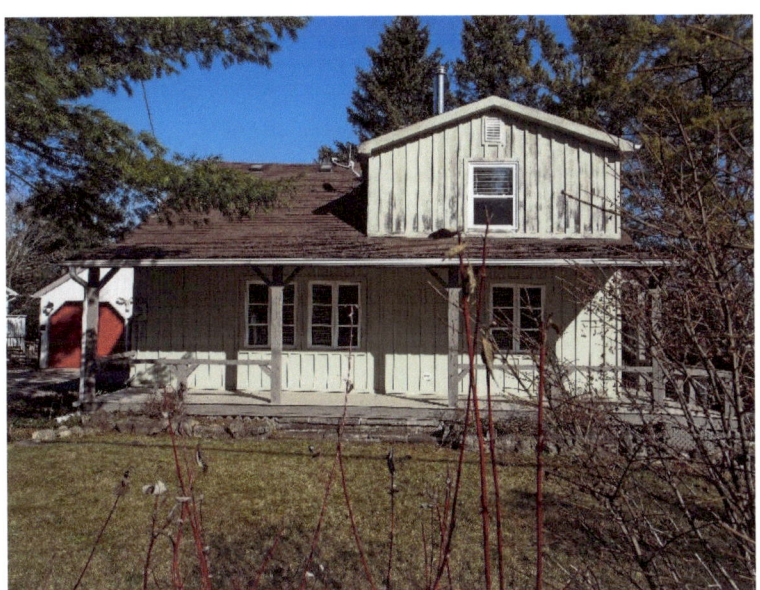

590 Bush Street – board and batten

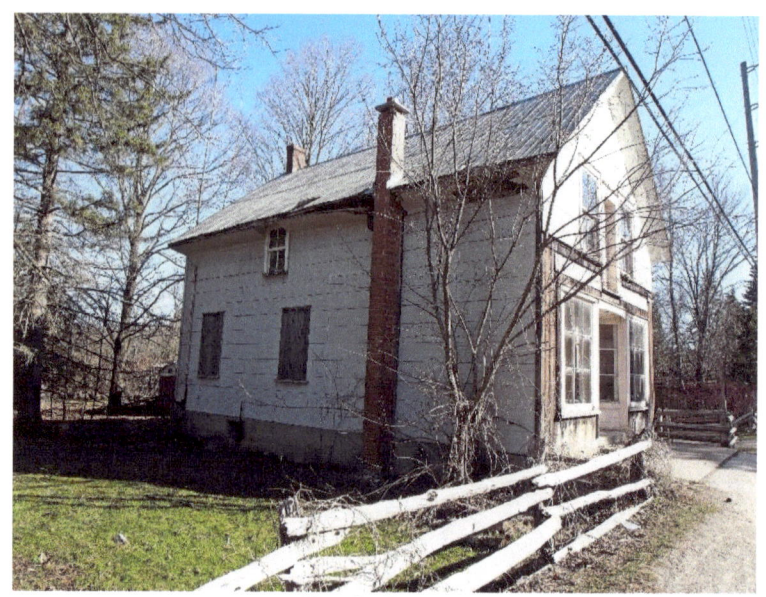
Bush Street

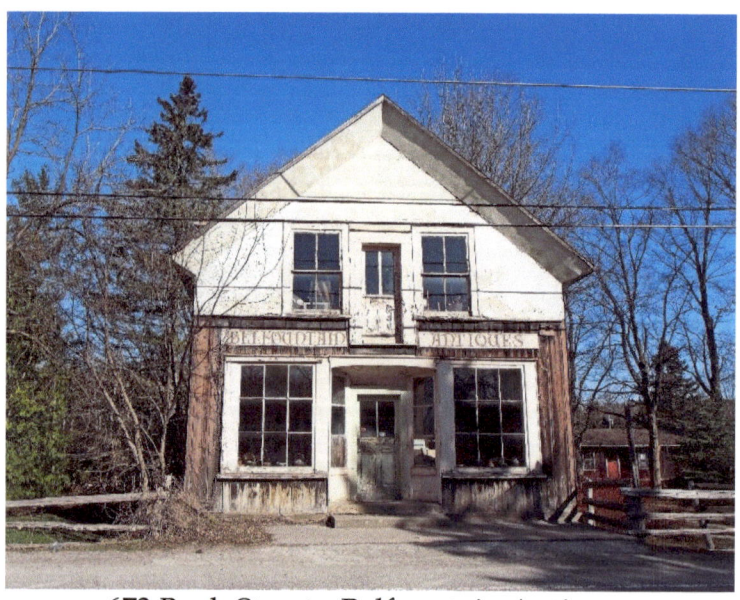
673 Bush Street - Belfountain Antiques

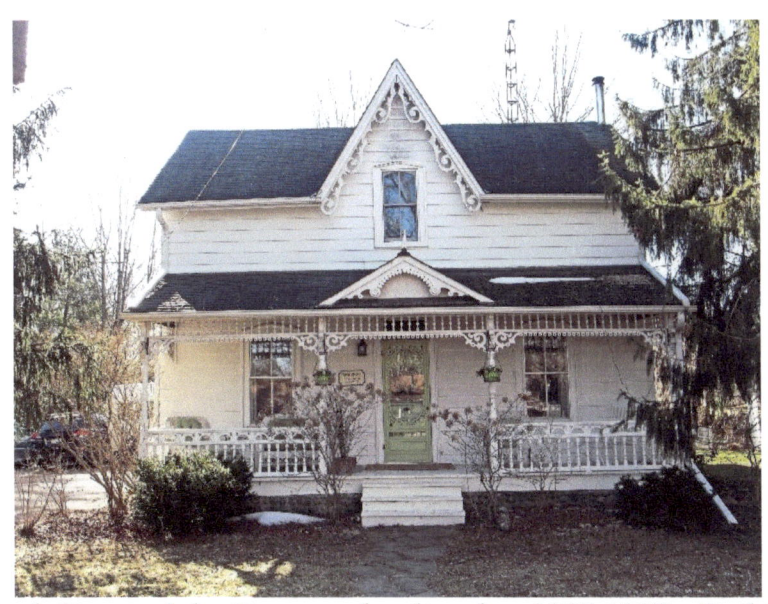

Bush Street - John Drury, schoolteacher 1905-1937 – Gothic, verge board trim on gable

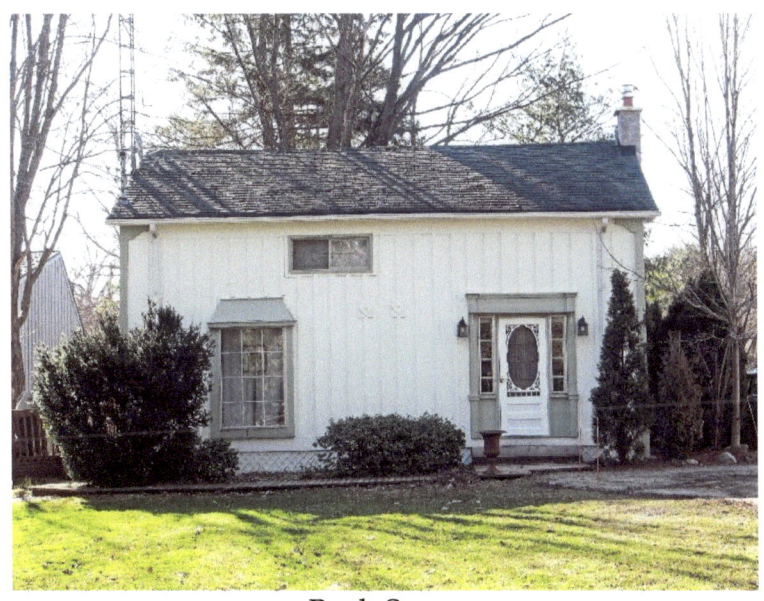

Bush Street

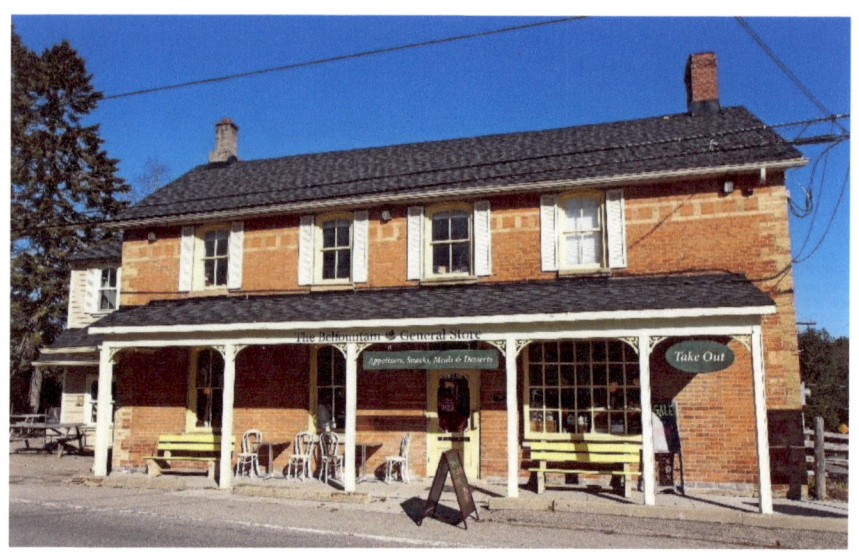

758 Bush Street – Belfountain General Store and Café – 1888 – dichromatic brickwork

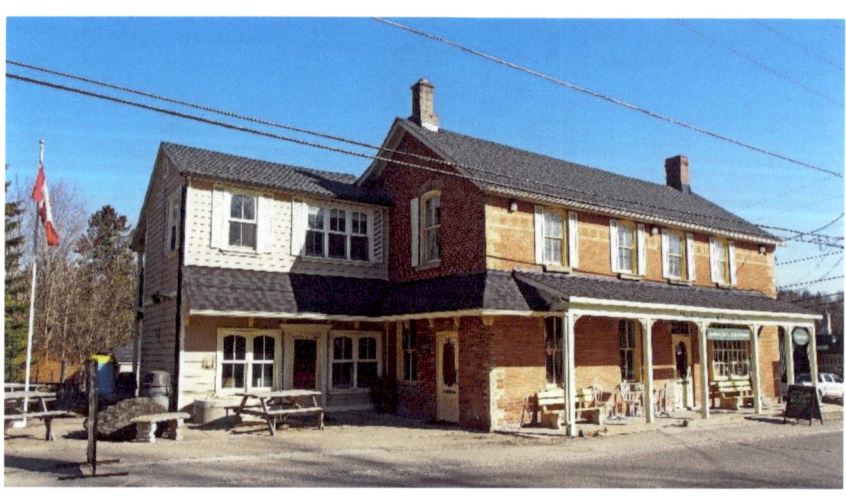

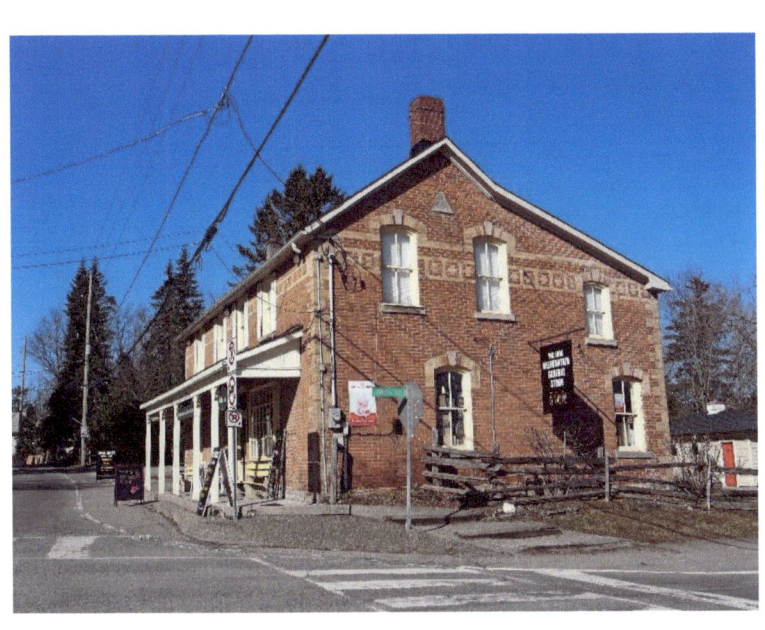

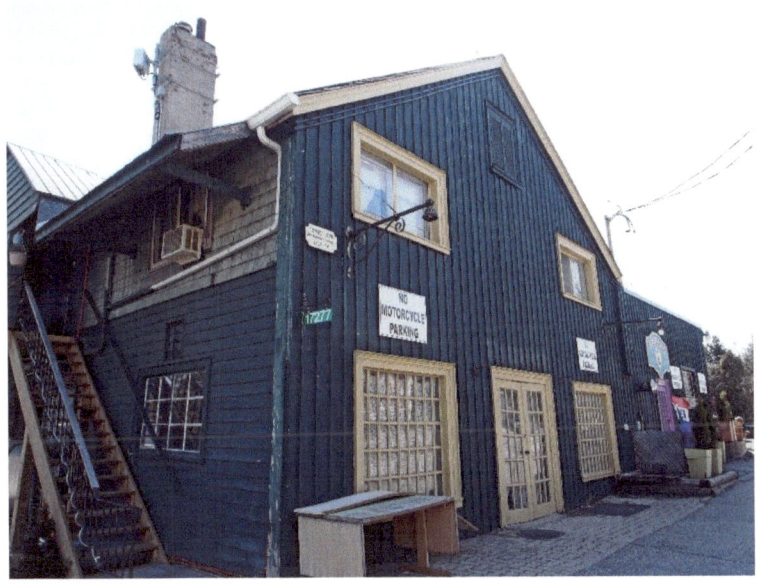

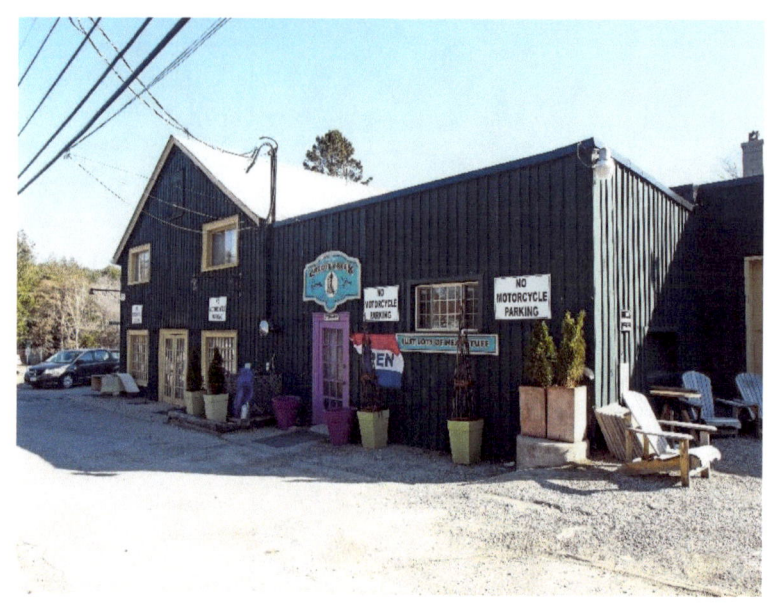

17277 Old Main Street – Trimble and Sons, Blacksmith and Garage 1924-1972

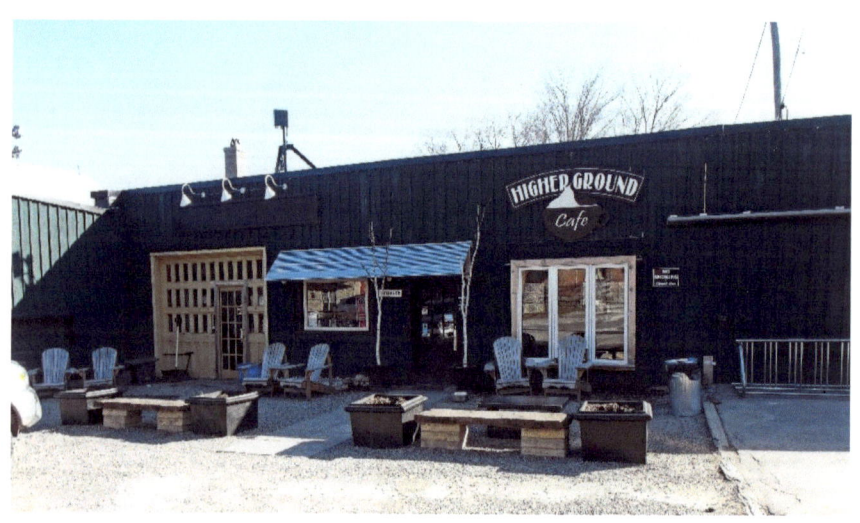

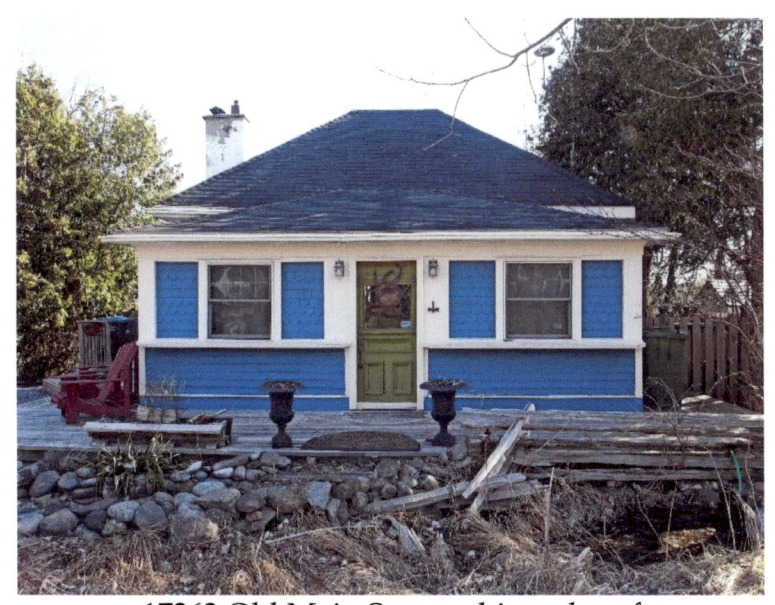

17263 Old Main Street – hipped roof

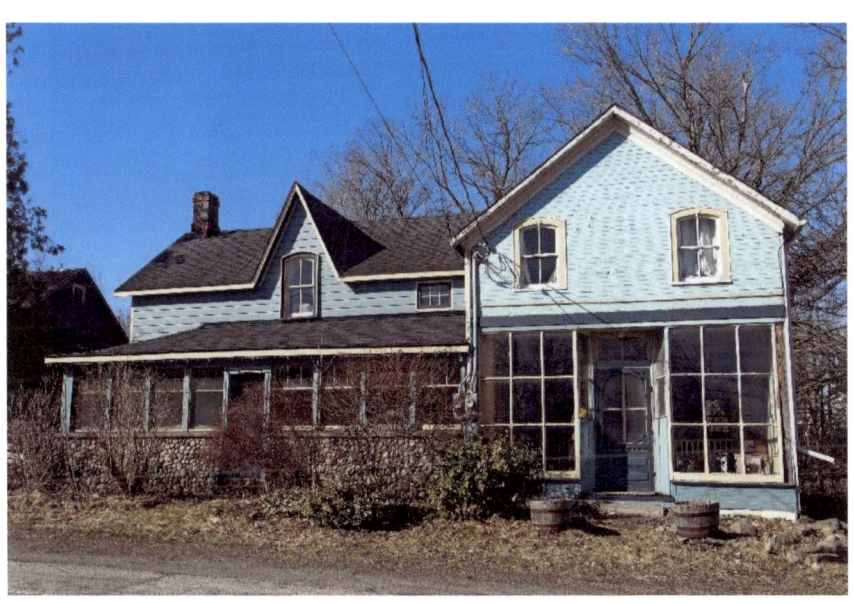

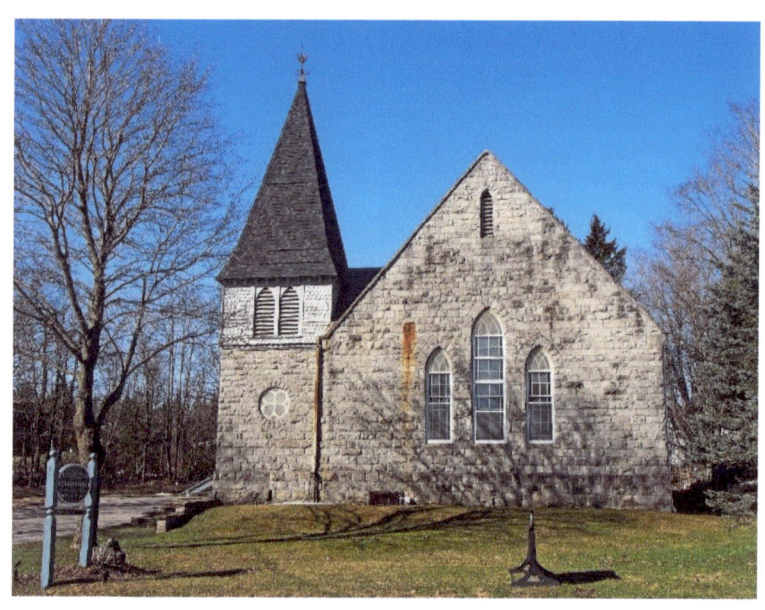

17258 Old Main Street – Belfountain Village Church founded 1835 – Gothic, lancet windows

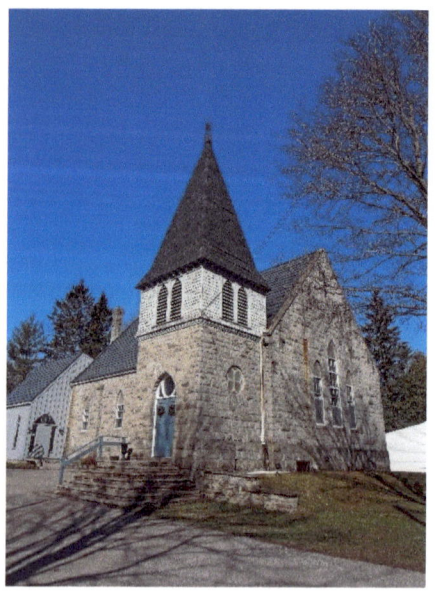

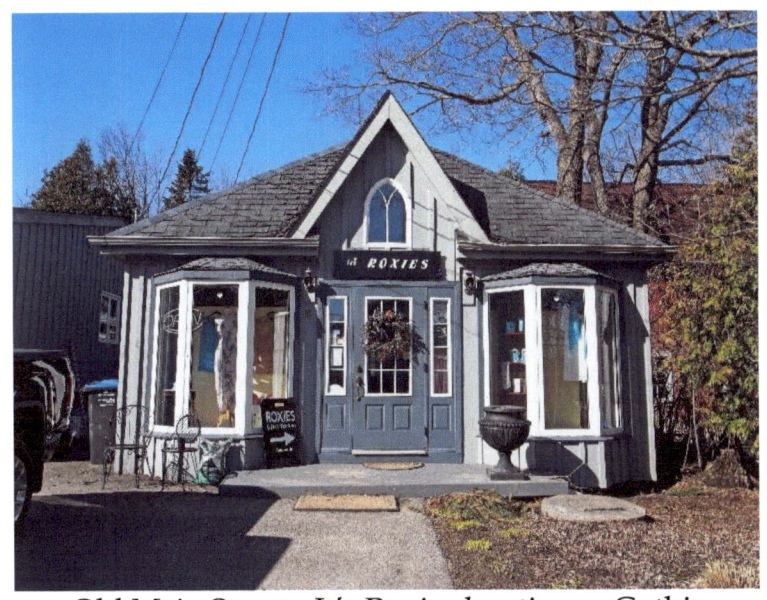

Old Main Street - It's Roxies boutique - Gothic

17228 Old Main Street

17227 Old Main Street

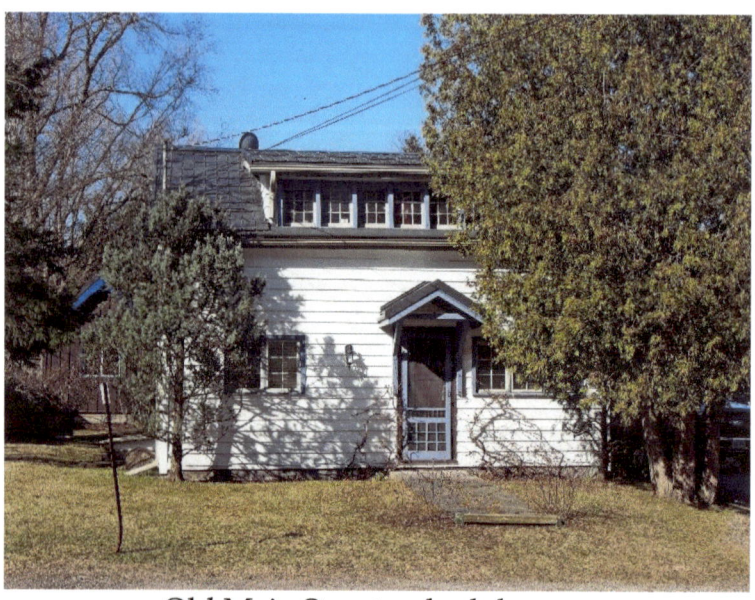
Old Main Street – shed dormer

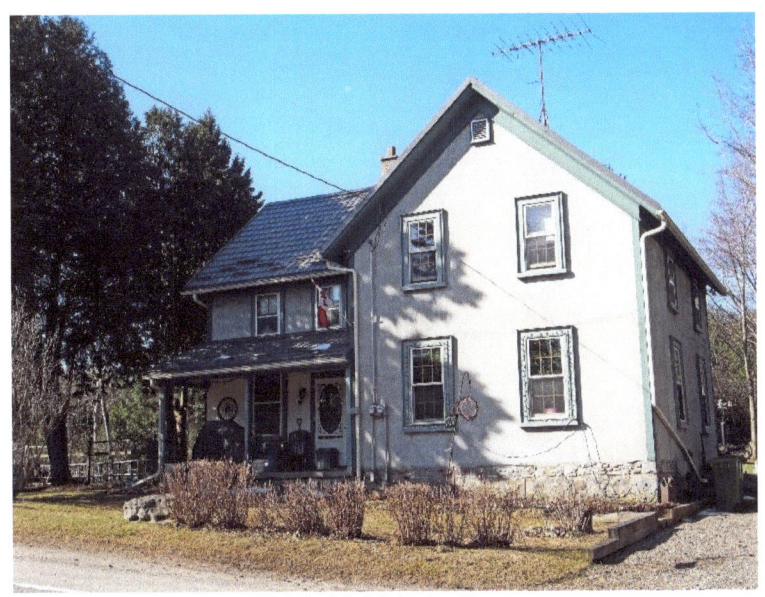

17216 Old Main Street

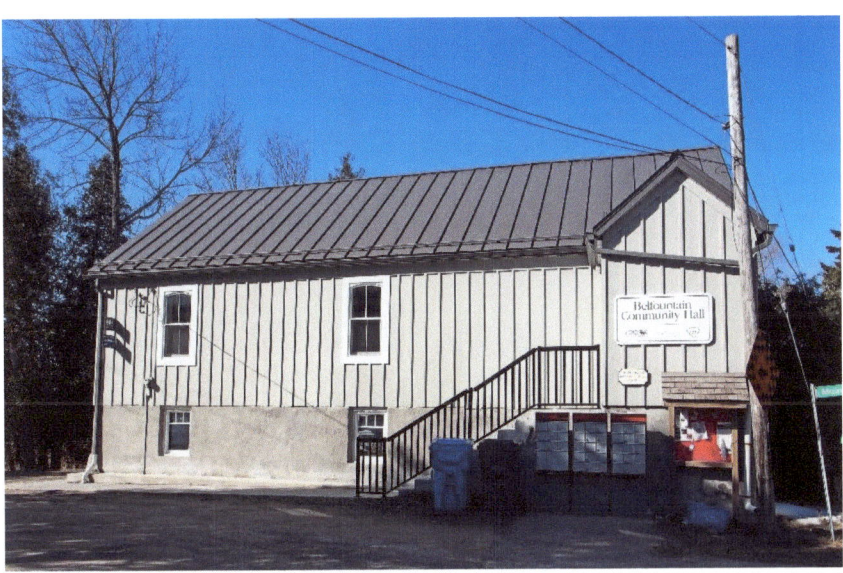

17204 Main Street - Belfountain Community Hall – Public Hall and Mechanics' Institute 1893

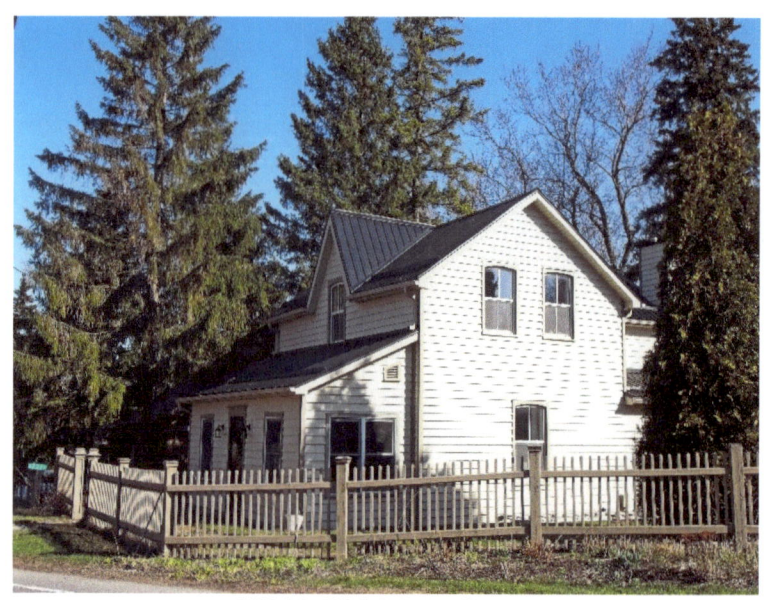

17211 Old Main Street

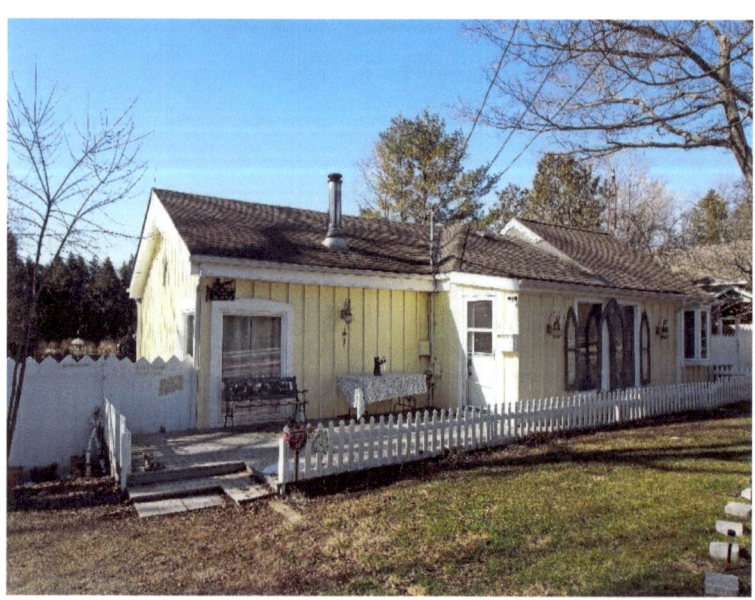

17162 Old Main Street – Honeycombe Cottage

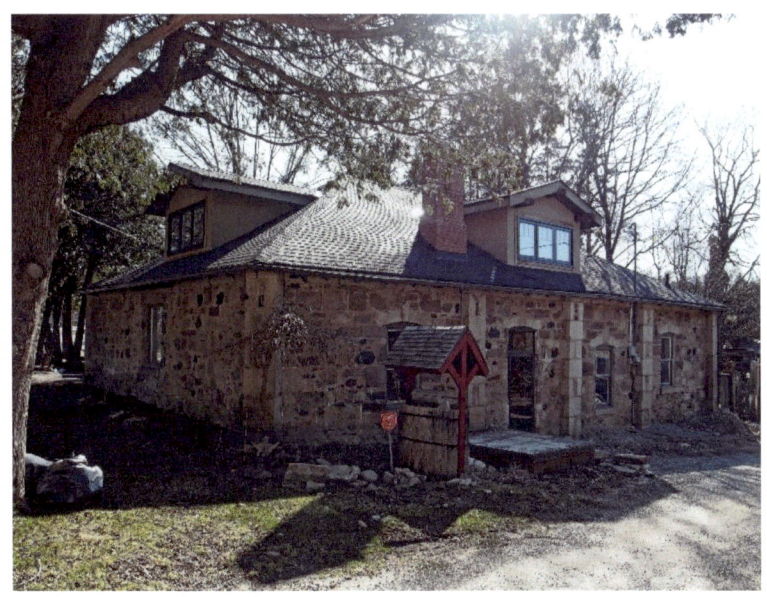

Stone building, dormers

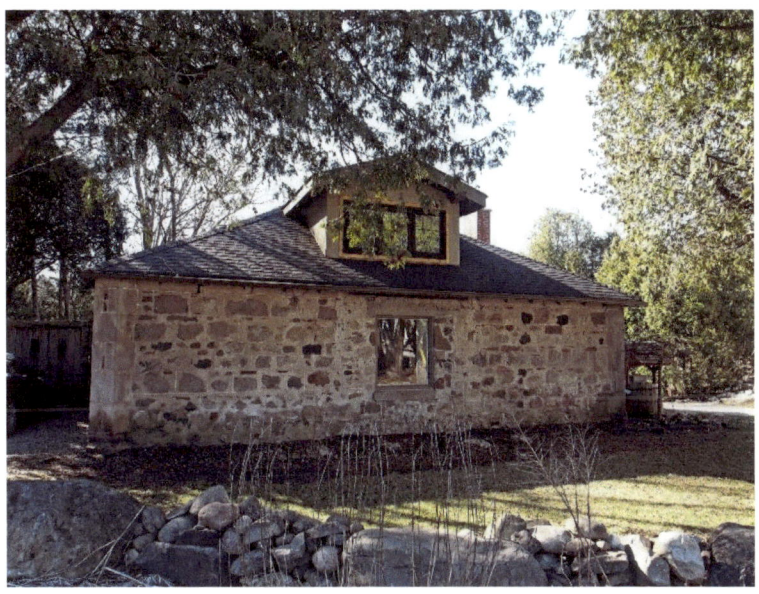

17180 Old Main Street

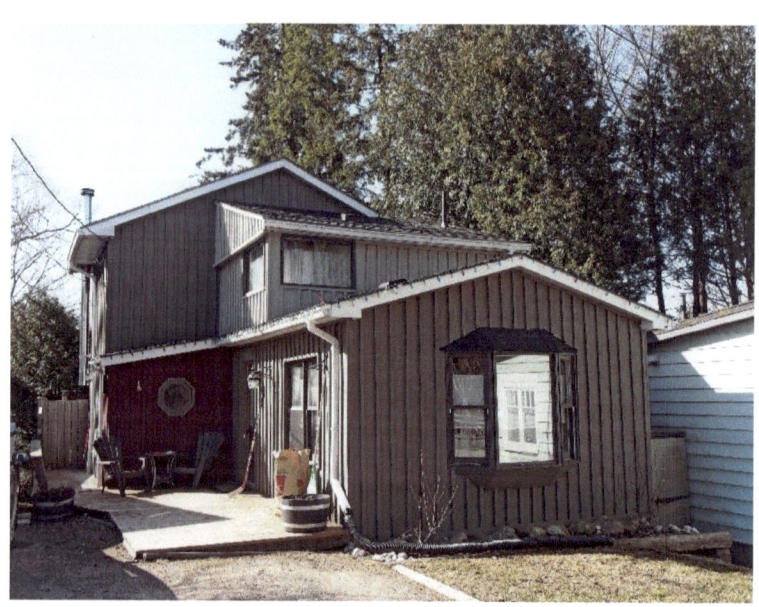

17186 Old Main Street

17190 Old Main Street

17217 Old Main Street

17228 Old Main Street

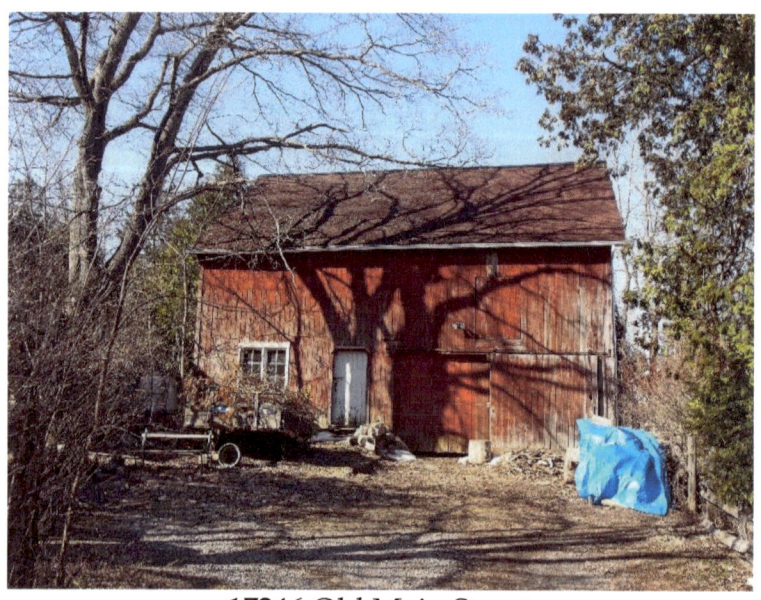

17246 Old Main Street

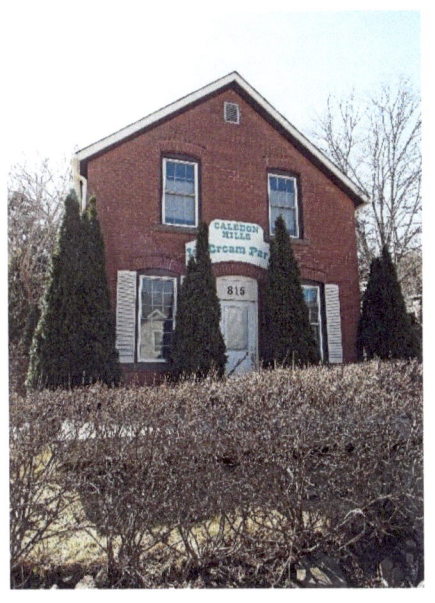

815 Forks of the Credit Road – Caledon Hills Ice Cream Parlor

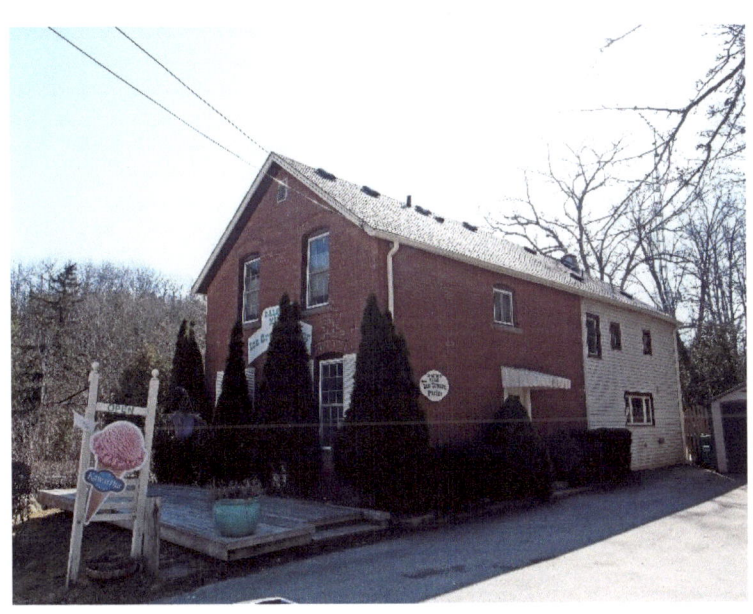

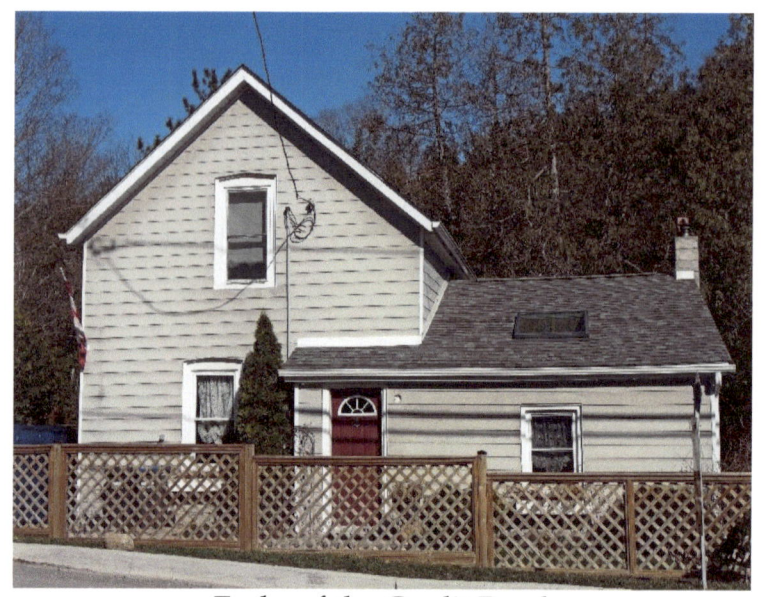

Forks of the Credit Road

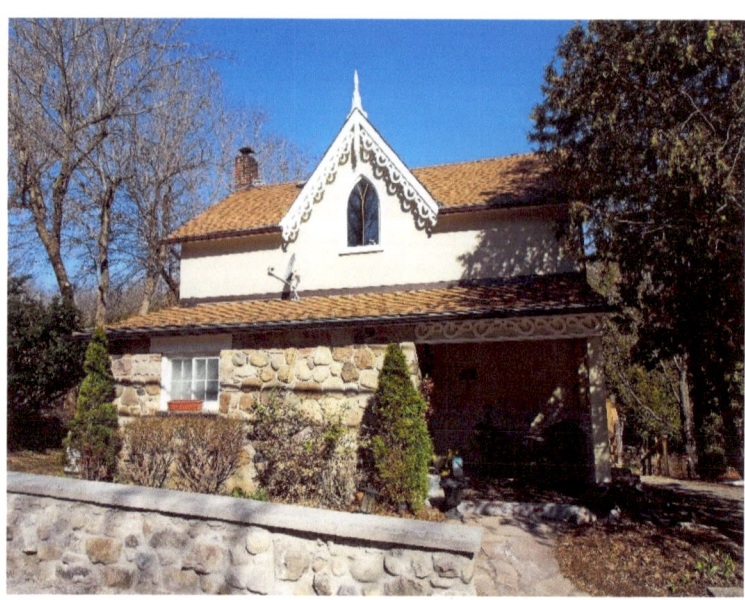

804 Forks of the Credit Road – verge board trim and finial on gable

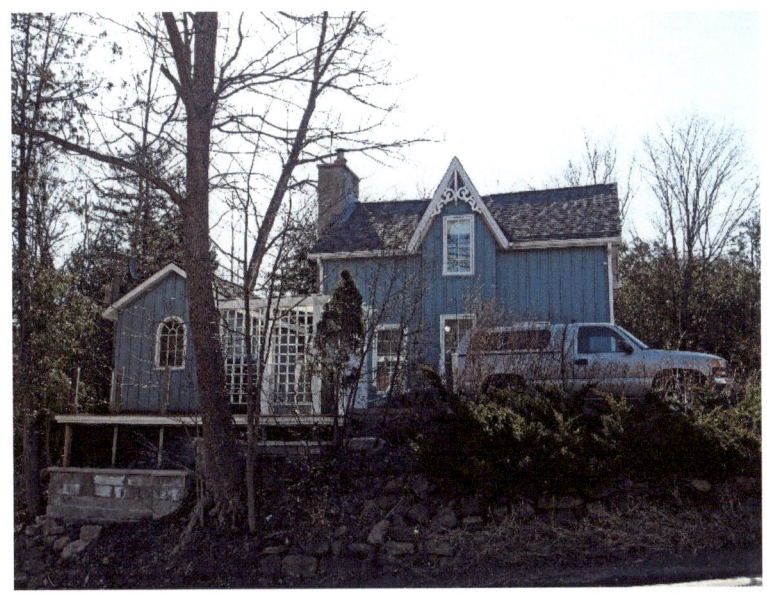

Forks of the Credit Road – Gothic, verge board trim

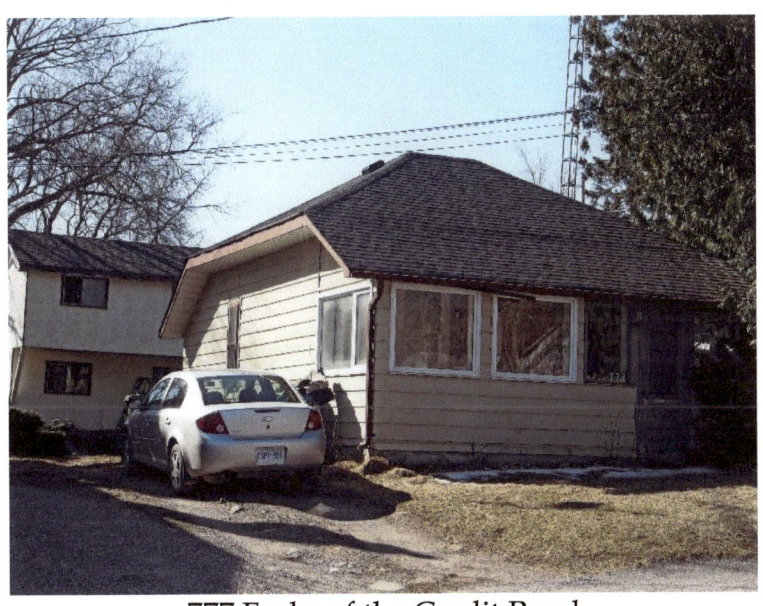

777 Forks of the Credit Road

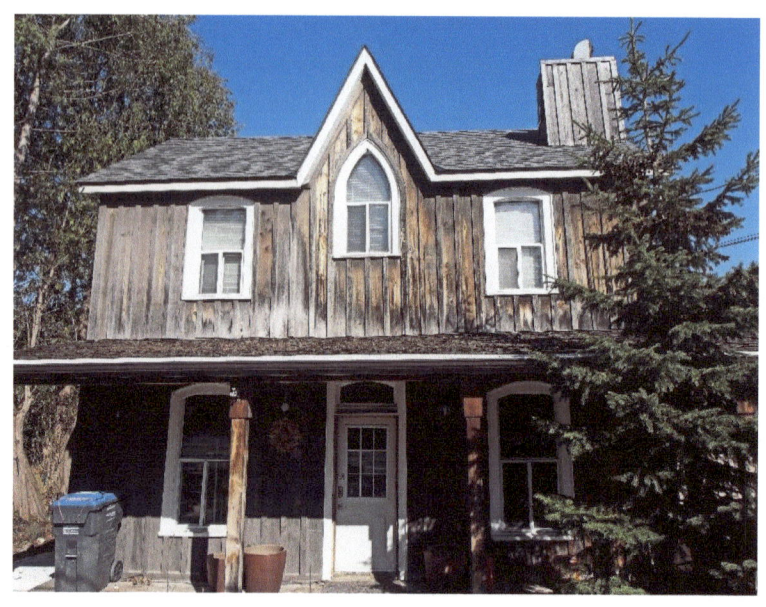

792 Forks of the Credit Road – Belfountain Inn

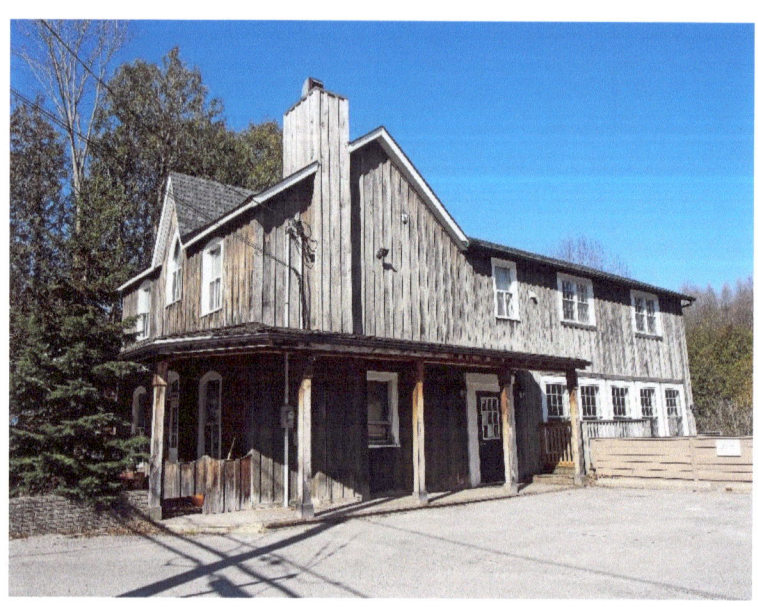

Forks of the Credit Road

Forks of the Credit Road

Forks of the Credit Road

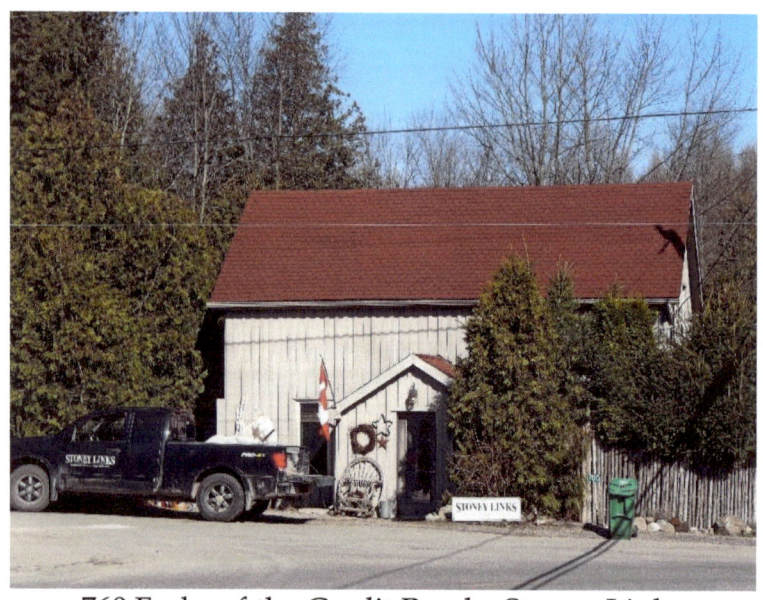

760 Forks of the Credit Road – Stoney Links

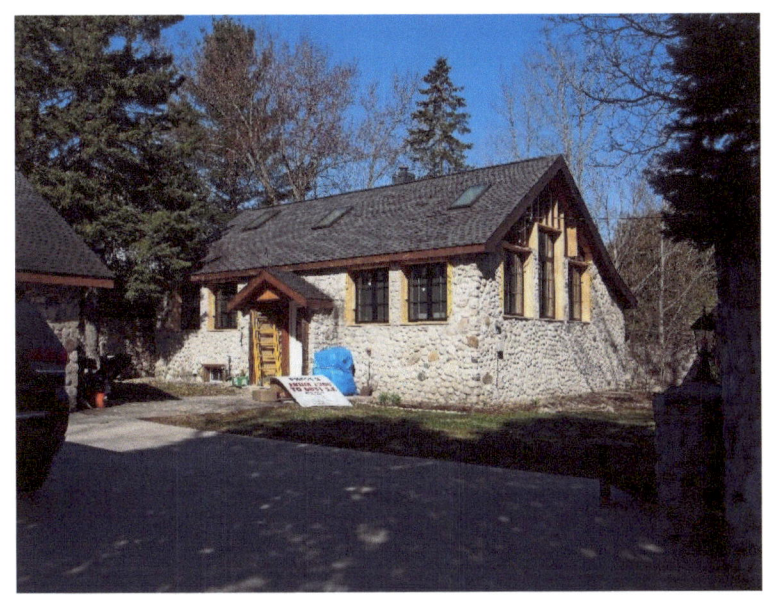

779 Forks of the Credit Road - cobblestone

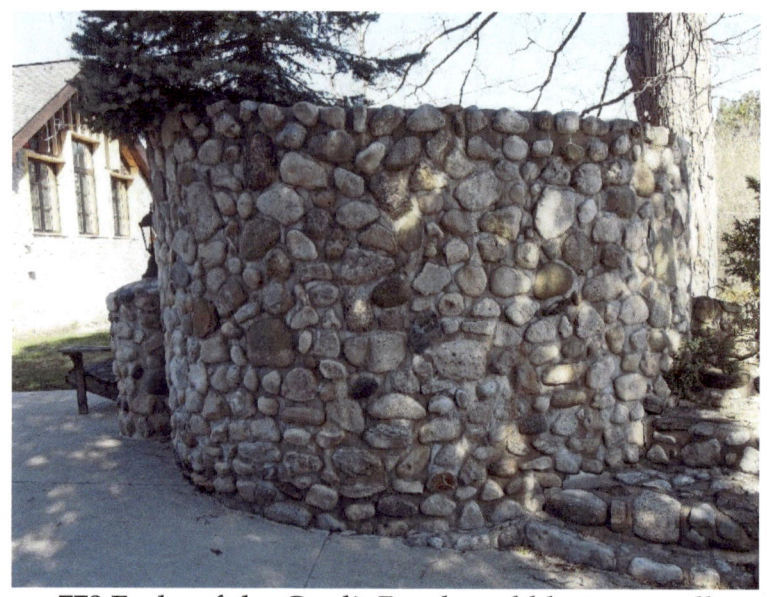

779 Forks of the Credit Road – cobblestone wall

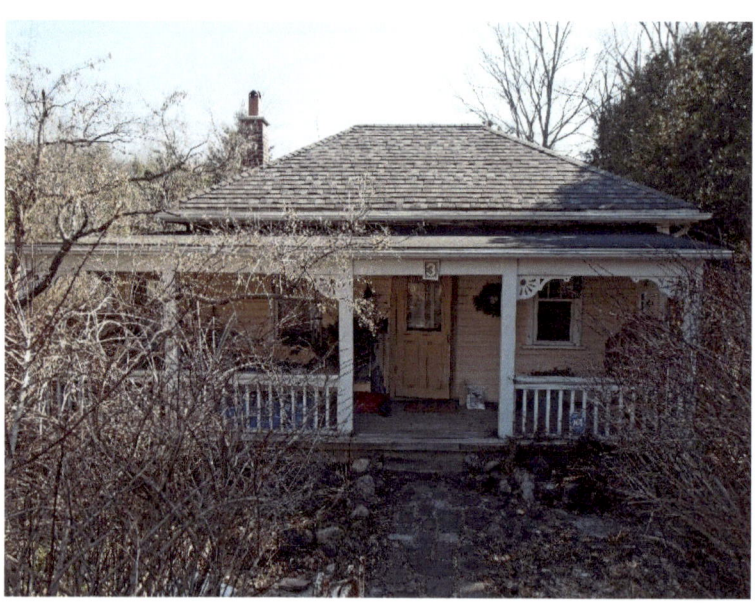

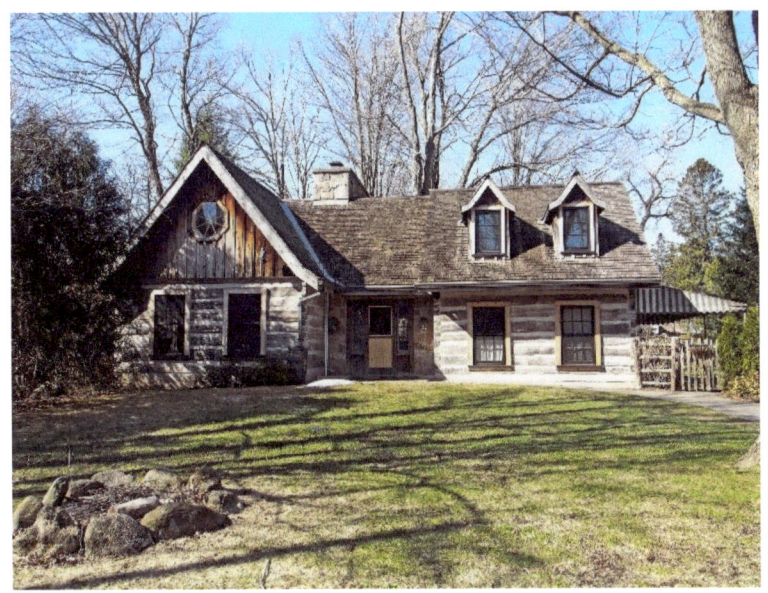

Log cabin

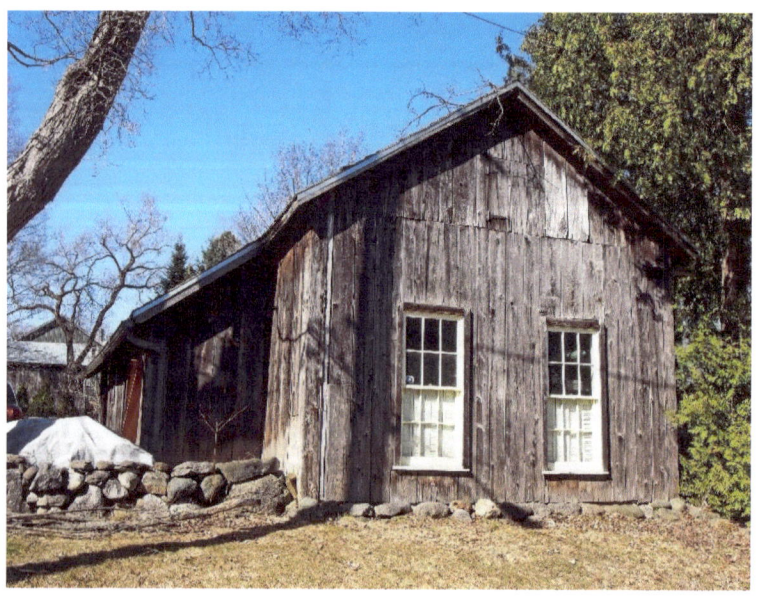

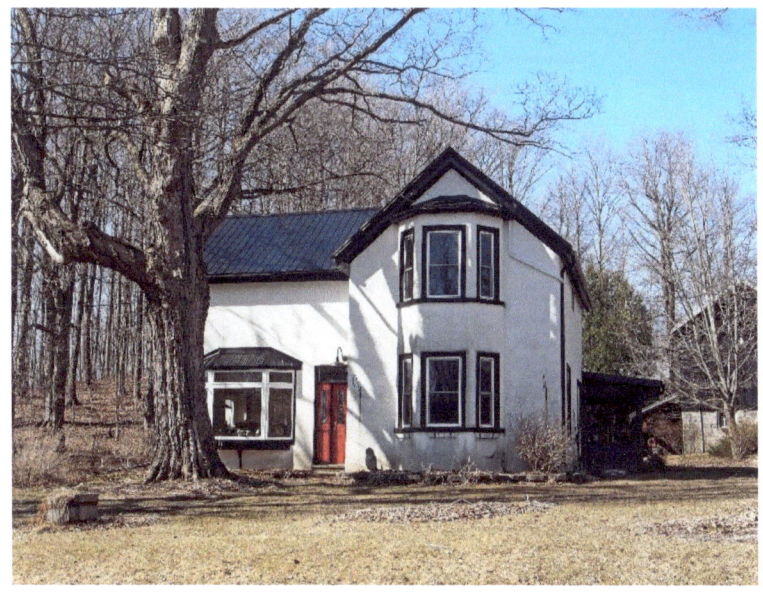

Two-story bay window in gable, one-story bay to left of door

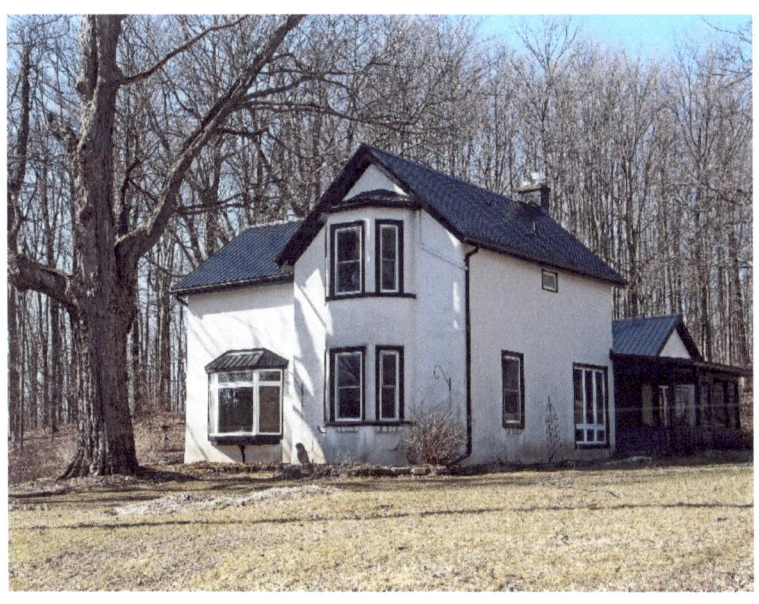

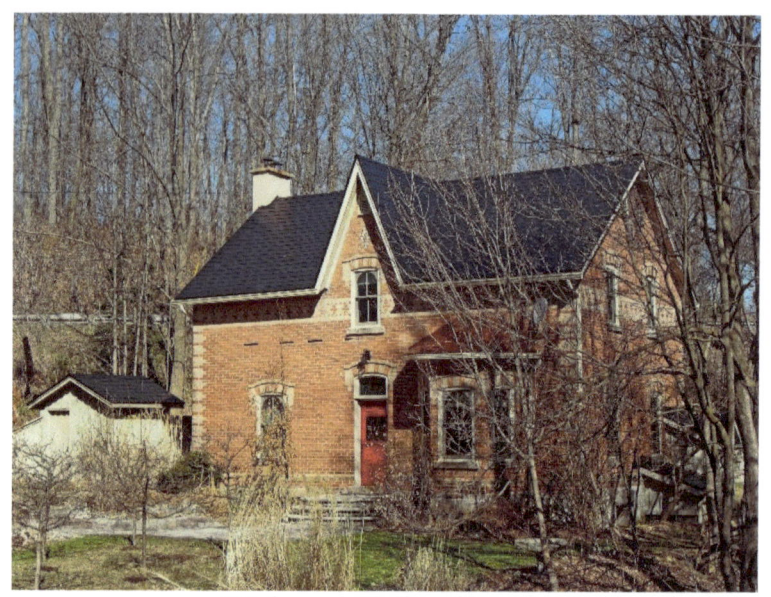
Dichromatic brickwork

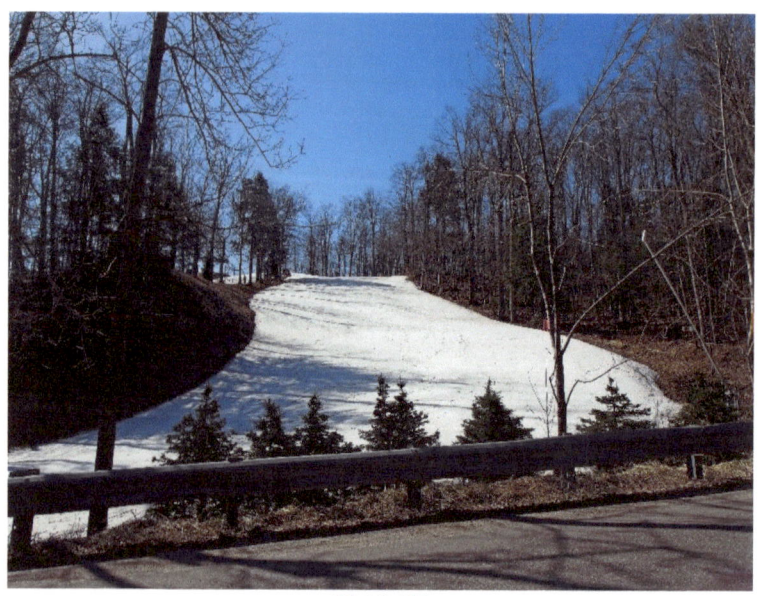
Ski hill

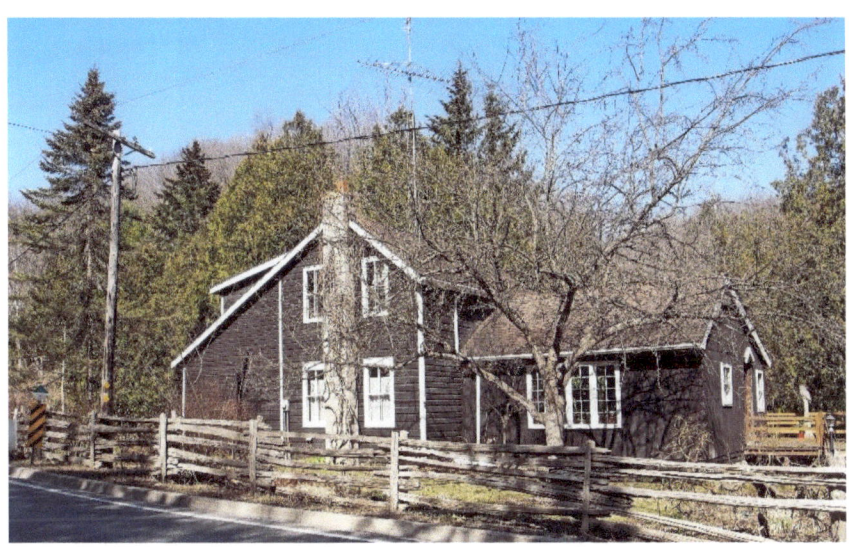

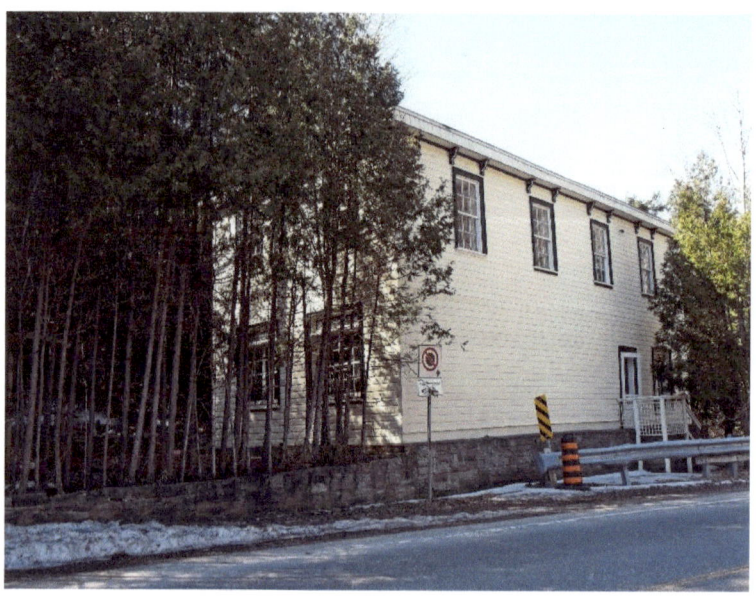

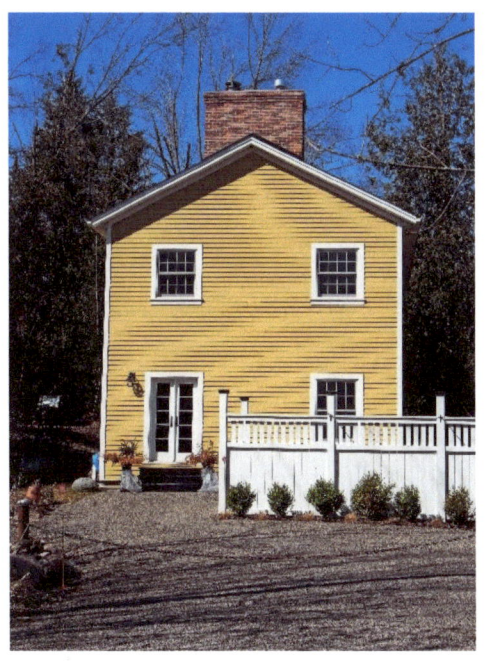

Ivy House – Forks of the Credit

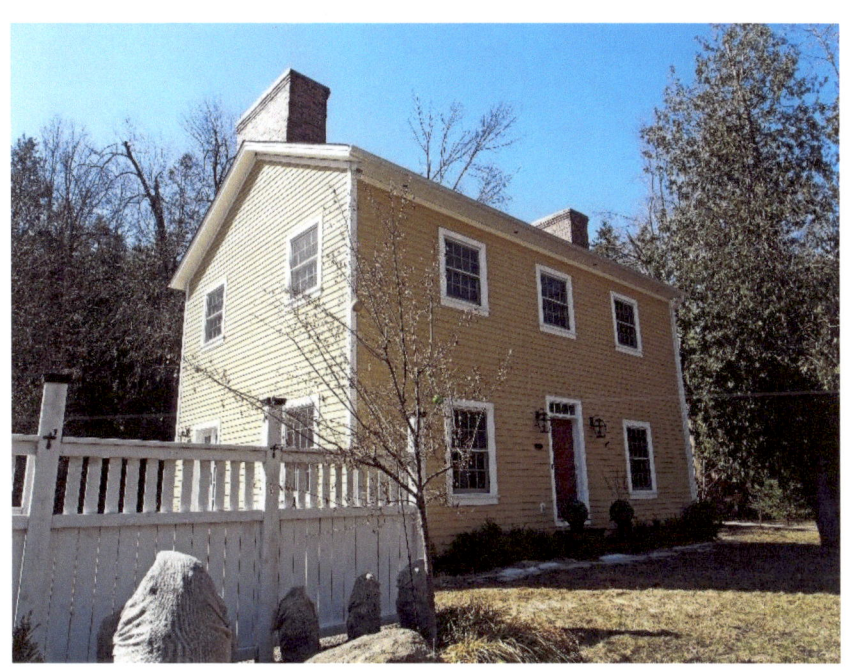

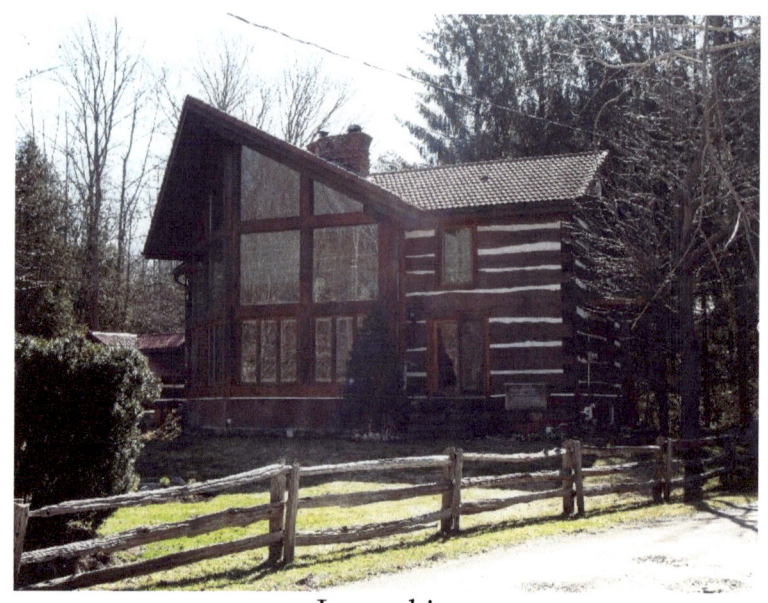
Log cabin

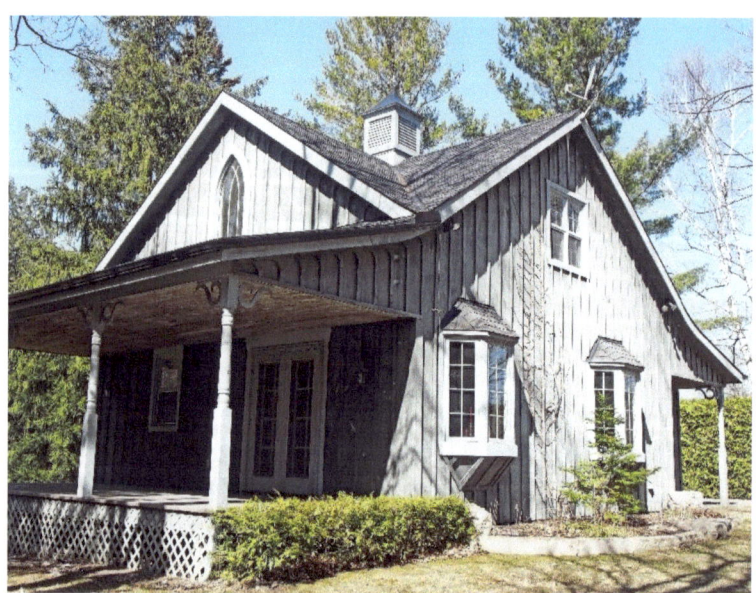
Board and batten

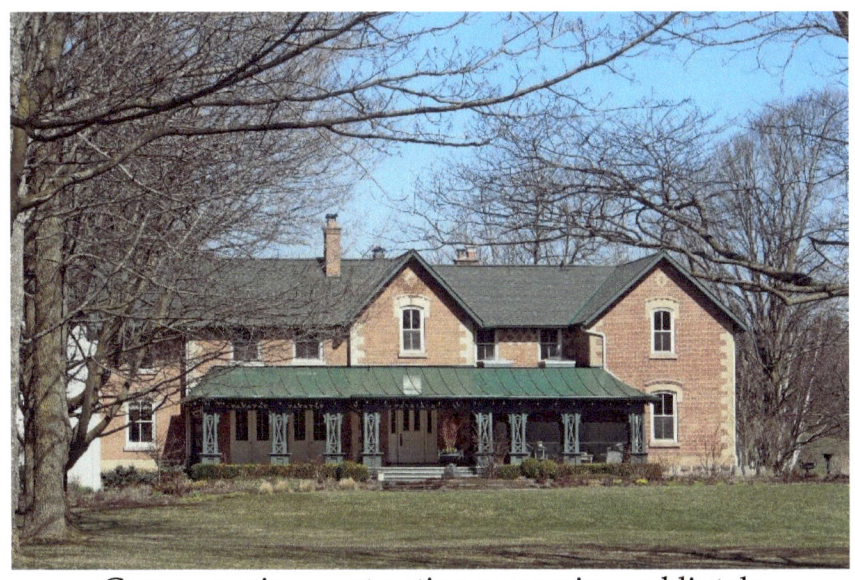

Corner quoins, contrasting voussoirs and lintels

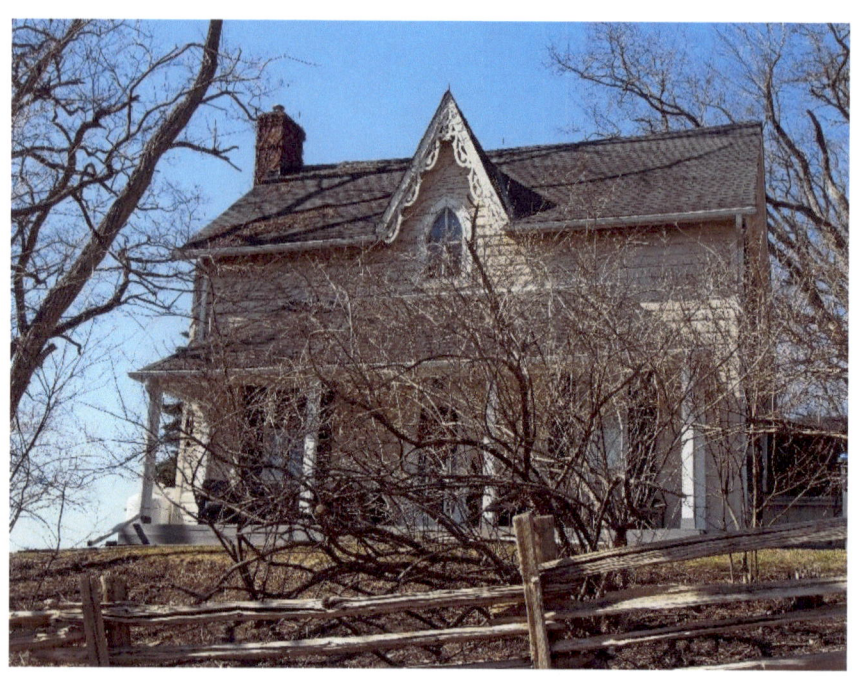

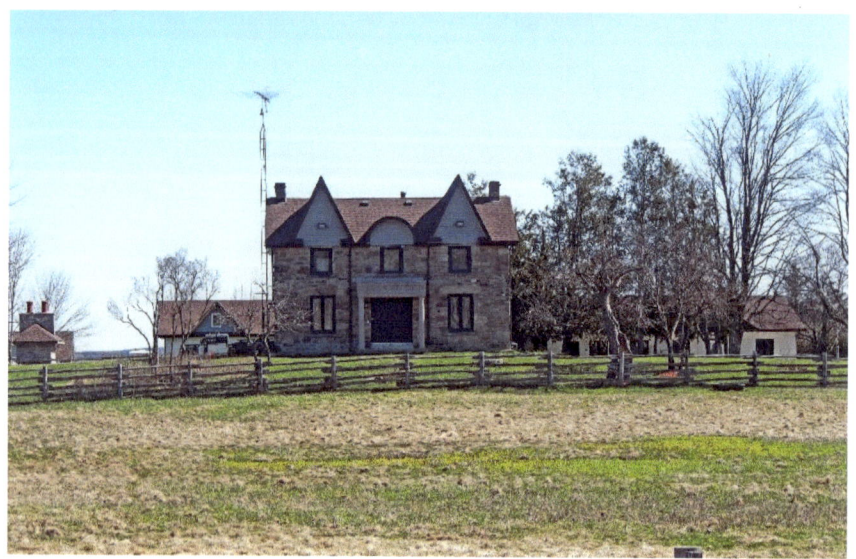

Inglewood

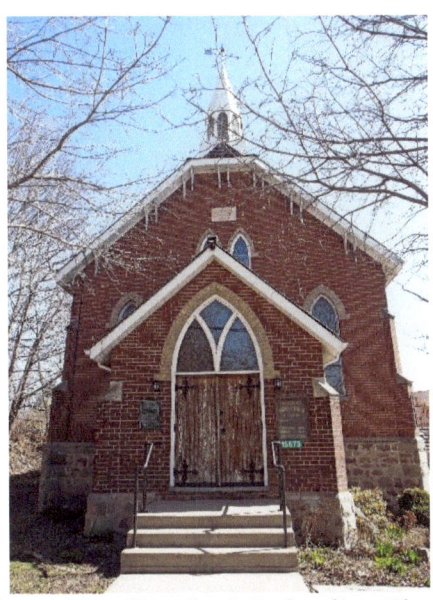

15673 McLaughlin Road – Methodist Church 1888 – Inglewood United Church - Victorian Gothic – red and yellow brick

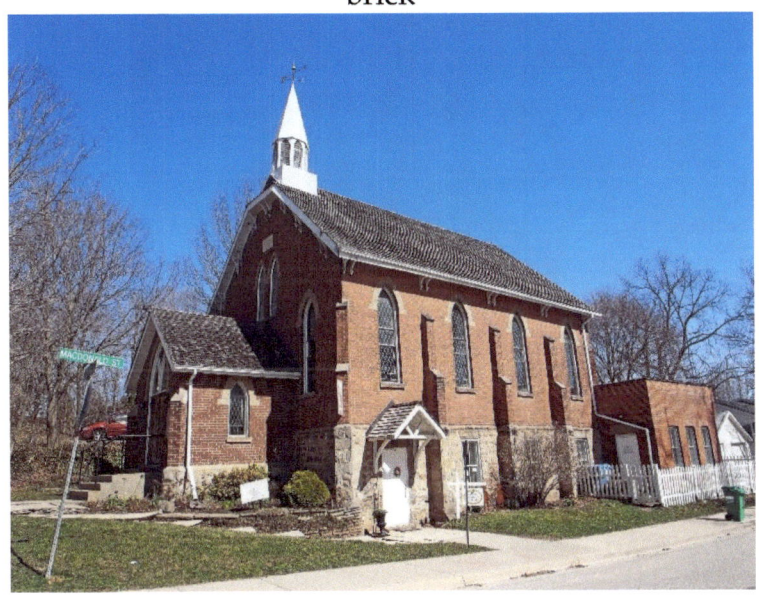

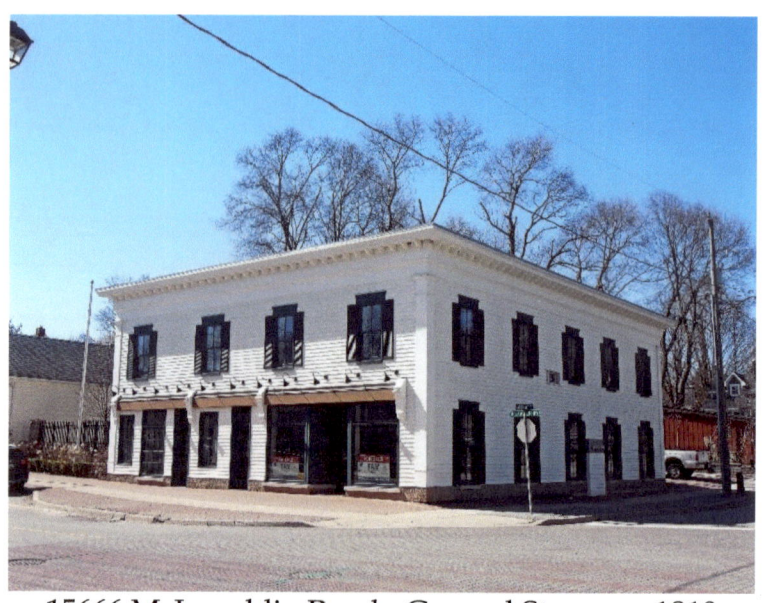

15666 McLaughlin Road - General Store – c. 1910

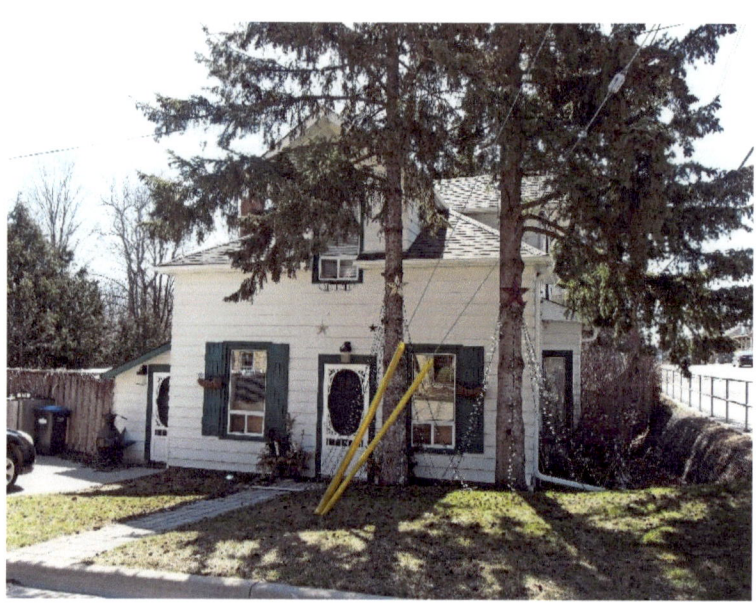

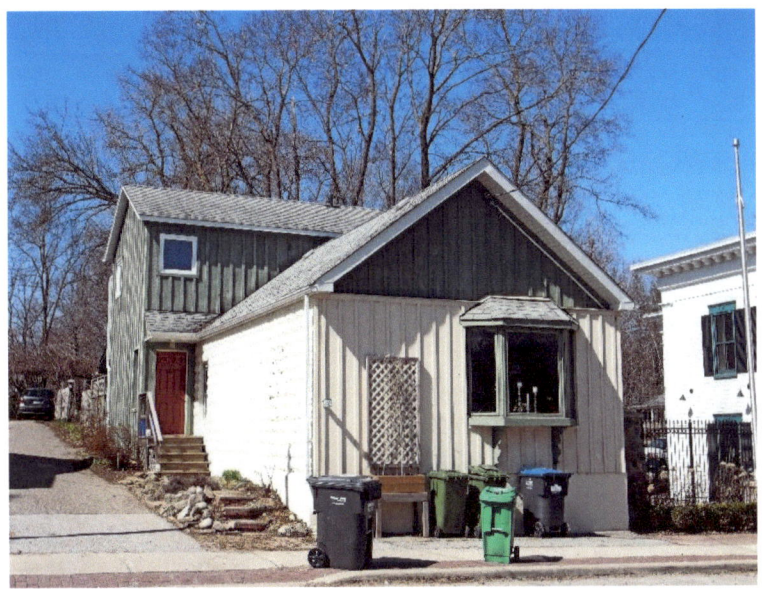

15654 McLaughlin Road - Butcher Shop – early 1900s - concrete block building

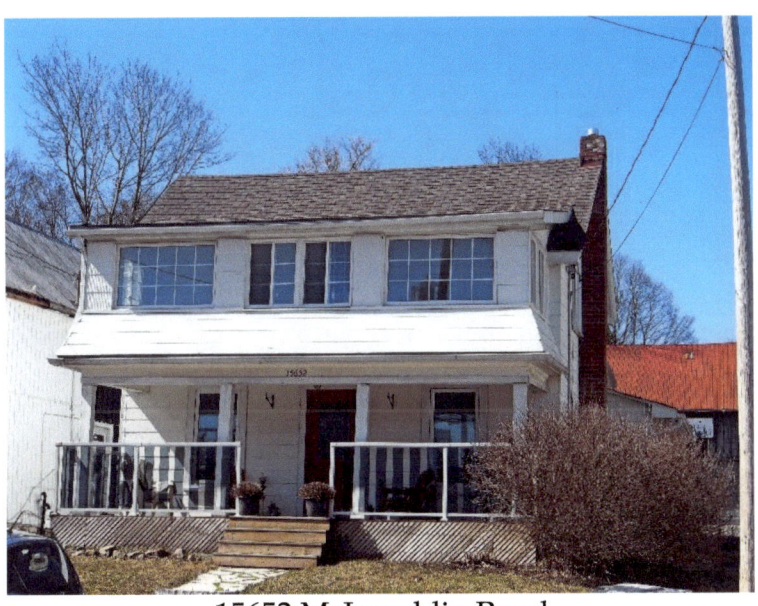

15652 McLaughlin Road

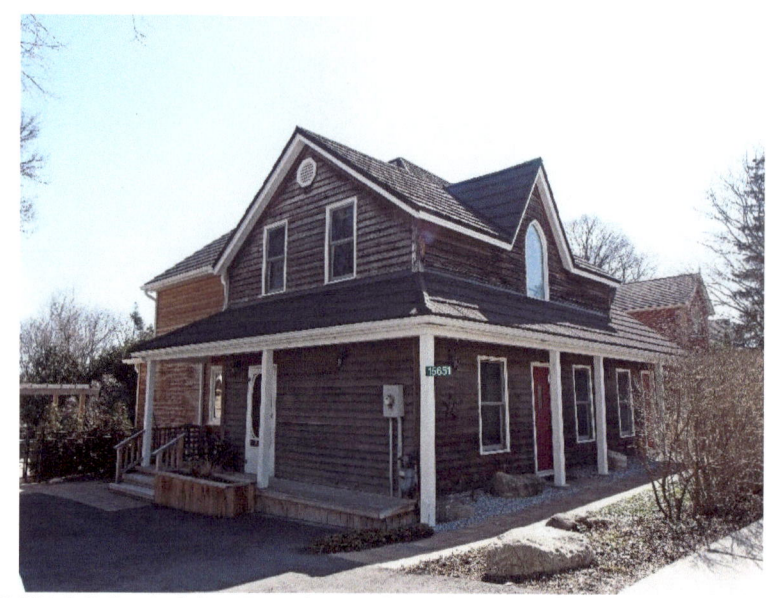

15651 McLaughlin Road - Tailor Shop – mid 1880s - Ontario Cottage

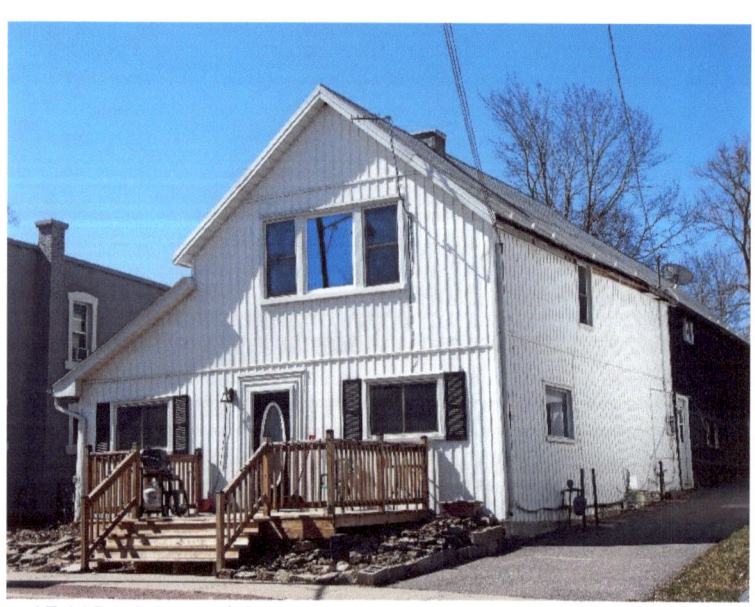

15648 McLaughlin Road - Hardware Store – c. 1890

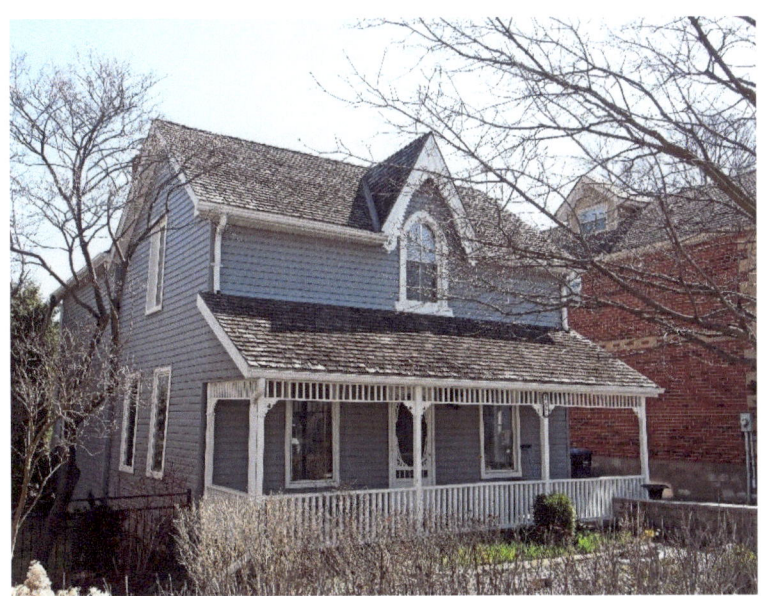

15641 McLaughlin Road - Northern Crown Bank – mid 1880s - Ontario Cottage with decorative Victorian Gothic trim details

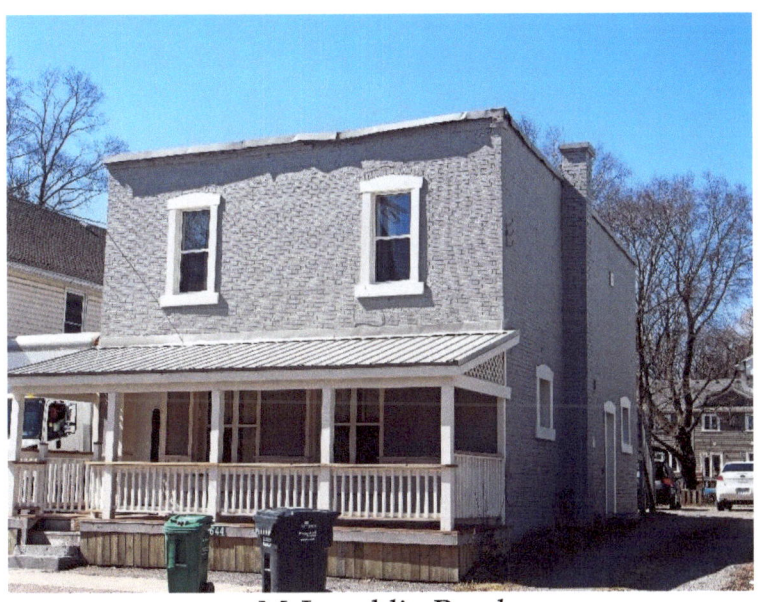

McLaughlin Road

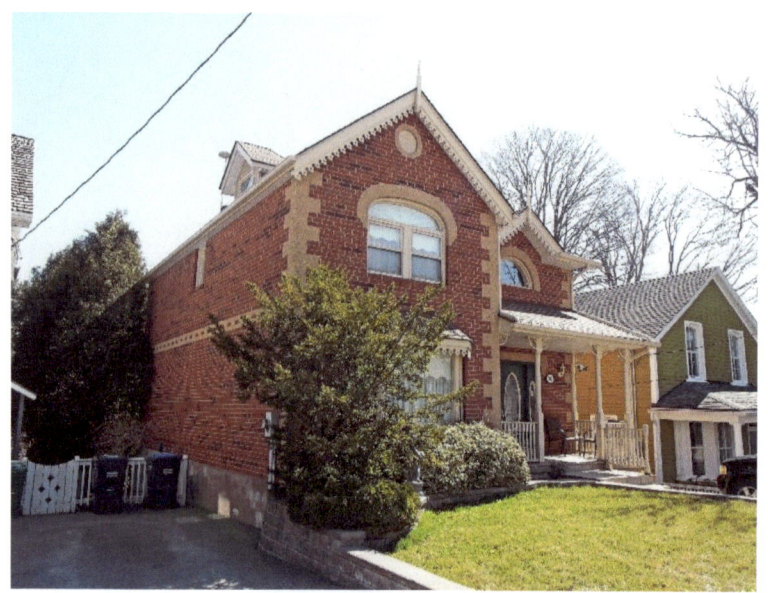

McLaughlin Road

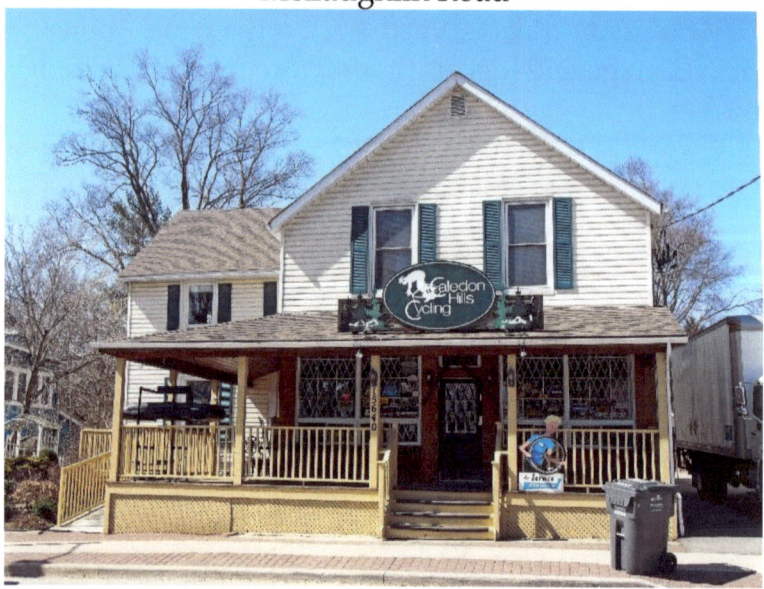

15640 McLaughlin Road – Caledon Hills Cycling - Victorian Gothic style building was Inglewood's first general store stocking all that was needed by the community in daily produce and dry goods.

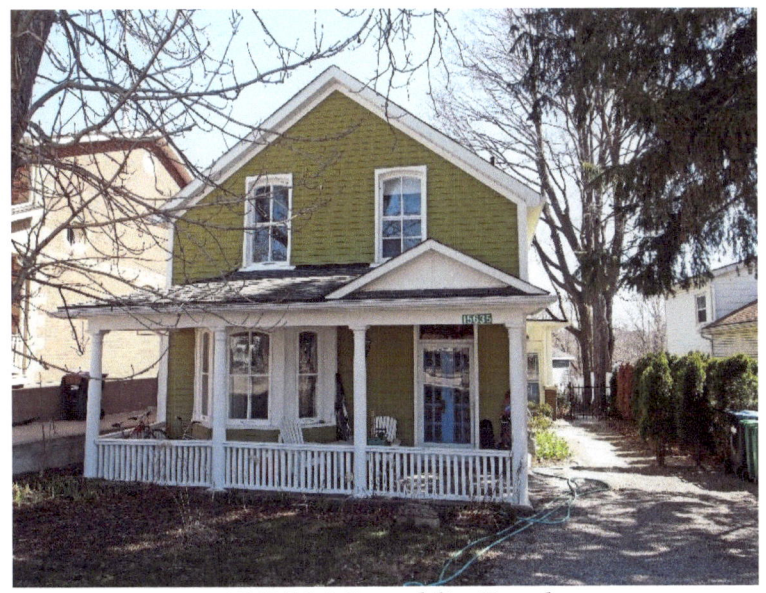

15635 McLaughlin Road

McLaughlin Road

McLaughlin Road

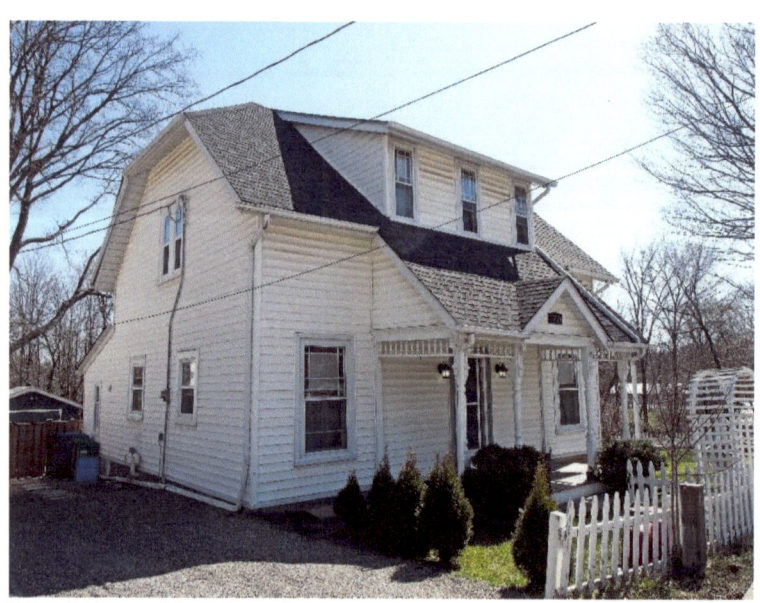

15629 McLaughlin Road – Neo-Colonial – gambrel roof, shed dormer

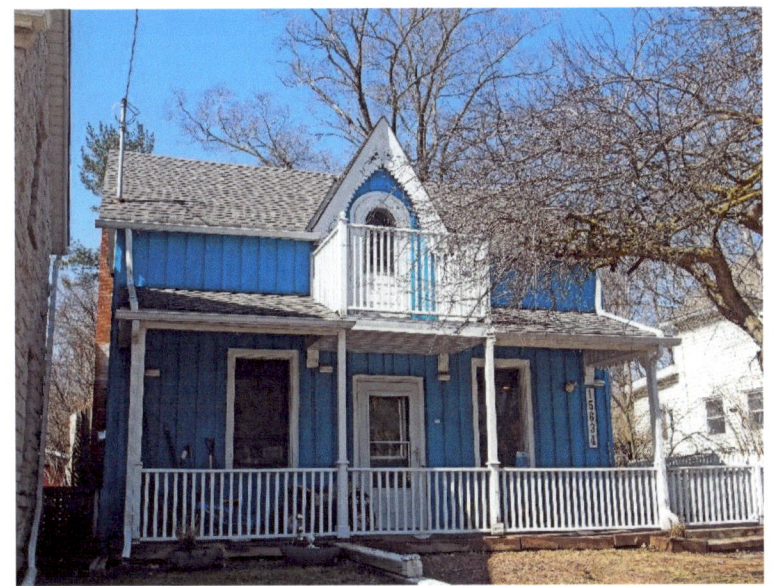
15634 McLaughlin Road

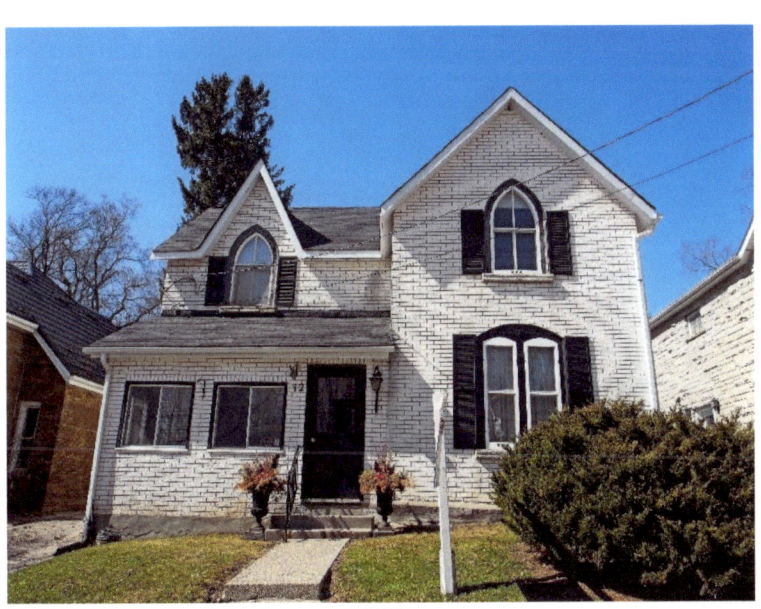
#12

McLaughlin Road

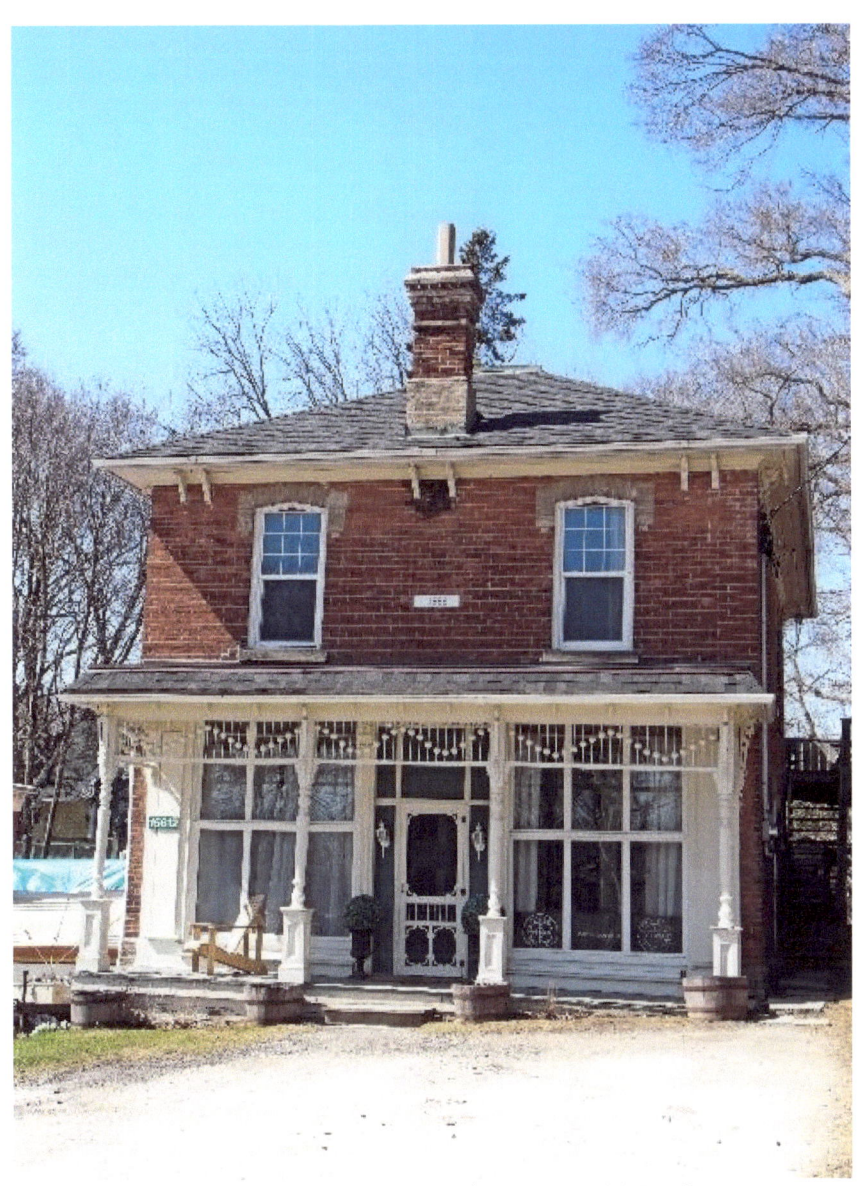

15612 McLaughlin Road – General Store – 1886 - George Merry built this red brick, hip roofed general store and located a bake-oven at the rear. Note the date stone, brick façade, paired brackets and the verandah's decorative spool-work trim.

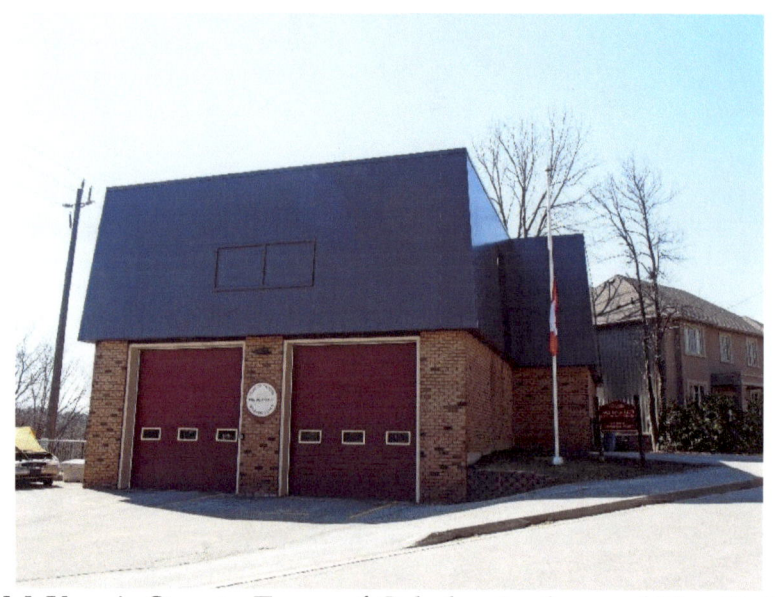

67 McKenzie Street - Town of Caledon Inglewood Fire Station

50 McKenzie Street

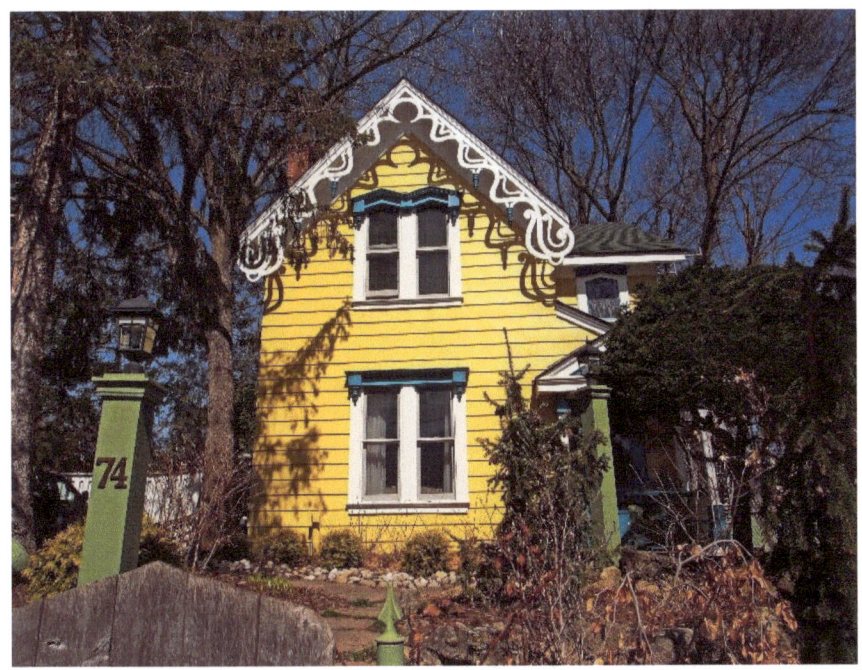

74 McKenzie Street – Victorian – c. 1890s - Ella Trought and Herb Spratt were given this 1½ storey frame house for their marriage in 1916 and lived here for over 50 years. Herb and his brother Harold ran the hardware store their father Arthur had operated.

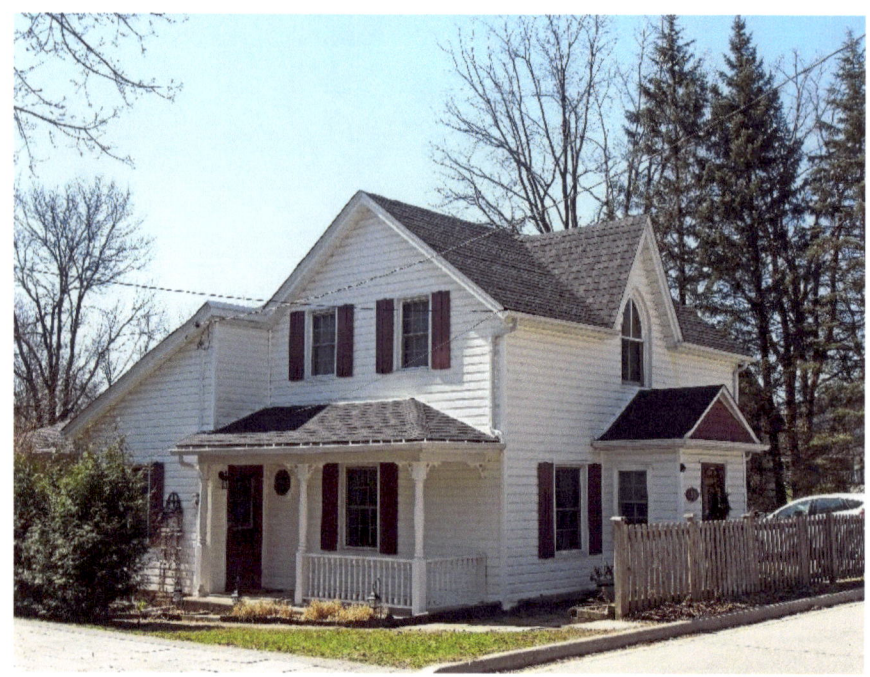

53 McKenzie Street - Mill Worker' Cottage – mid 1880s - This 1½ storey frame Ontario Cottage is built with a centre entry, steep centre gable and gothic window in a style known locally as Rural Gothic or Carpenter's Gothic. In 1905, Jacob Sithes purchased the house from mill owner David Graham.

32 McKenzie Street

30 Louise Street

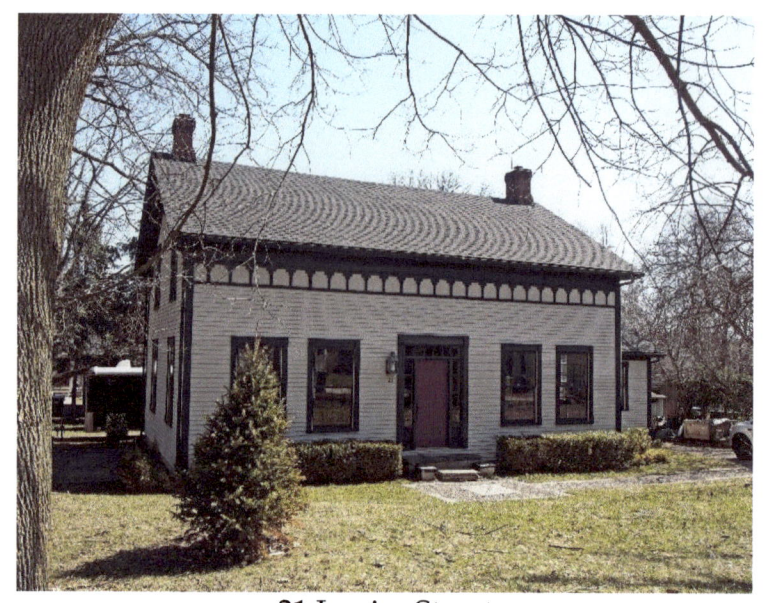

21 Louise Street

24 Louise Street

6 Louise Street

11 Lorne Street

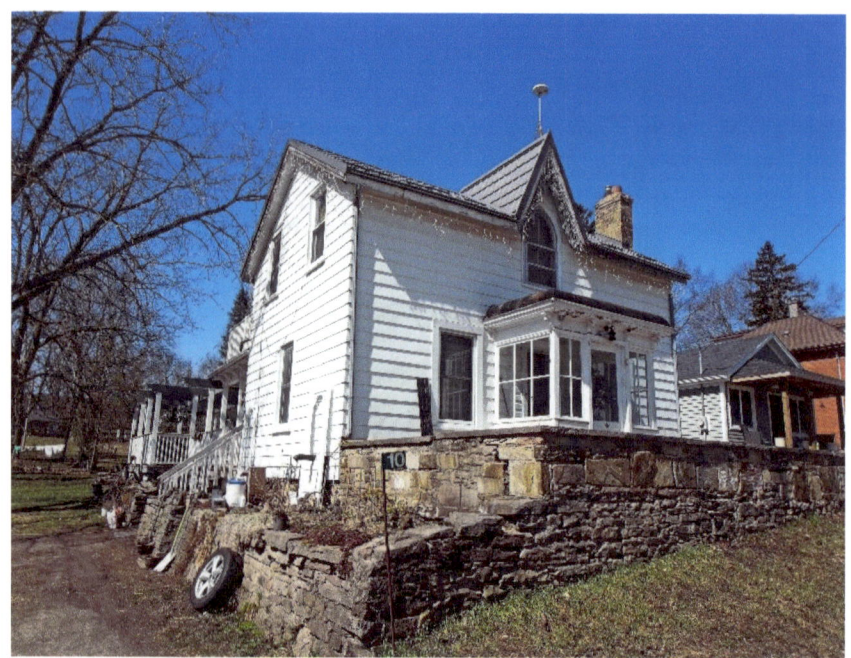

10 Lorne Street - Edward Trought House – c. 1890 - This 1½ storey Ontario Cottage with center entry, steep centre gable and Gothic window is decorated with Victorian fretwork and Italianate brackets.

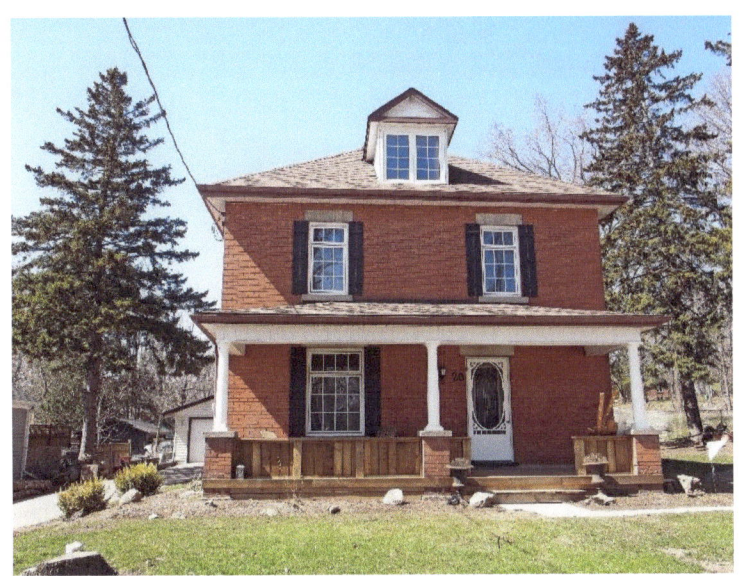

20 Lorne Street - Henry Sithe House – c. 1912 - This 'four square' house is built in the Edwardian Classical style characterized by an asymmetric floor plan, pyramidal hipped roof, large attic dormer and a full verandah; it has heavy limestone window lintels and sills. It was built for Annie Puckering and Henry Sithe, who was a railway foreman.

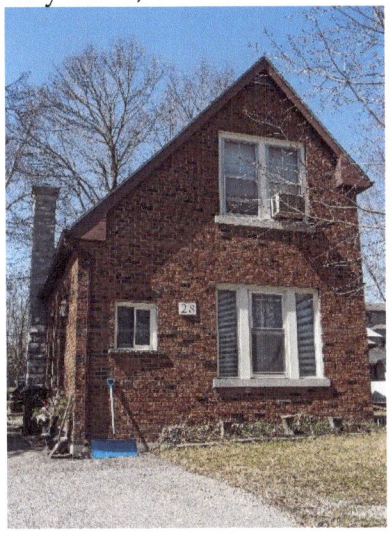

28 Lorne Street

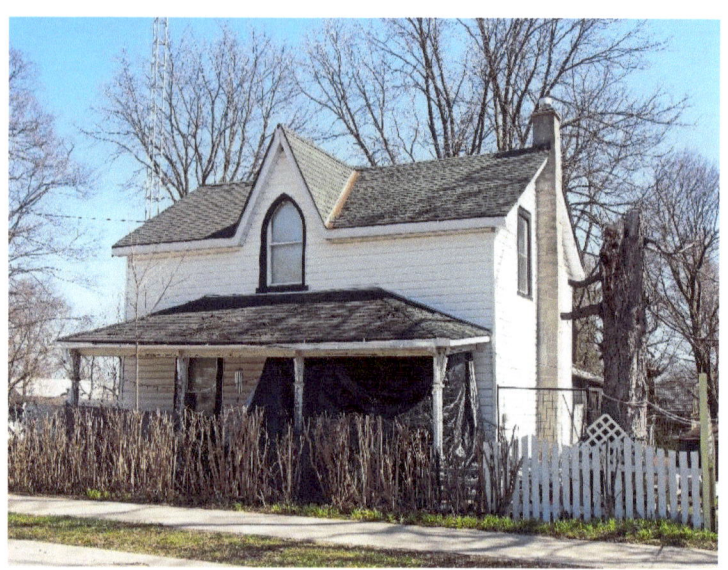

25 Lorne Street - William Maxwell House – mid 1880s – This is a frame Ontario Cottage built to house mill workers. It has a centre entry, symmetrically positioned windows, full verandah, steep centre gable and Gothic window. In 1888, mill owner David Graham sold it to local farmer, William Maxwell. Maxwell's son Dick and his wife Lucille Barshaw later became the second generation of the family to own it.

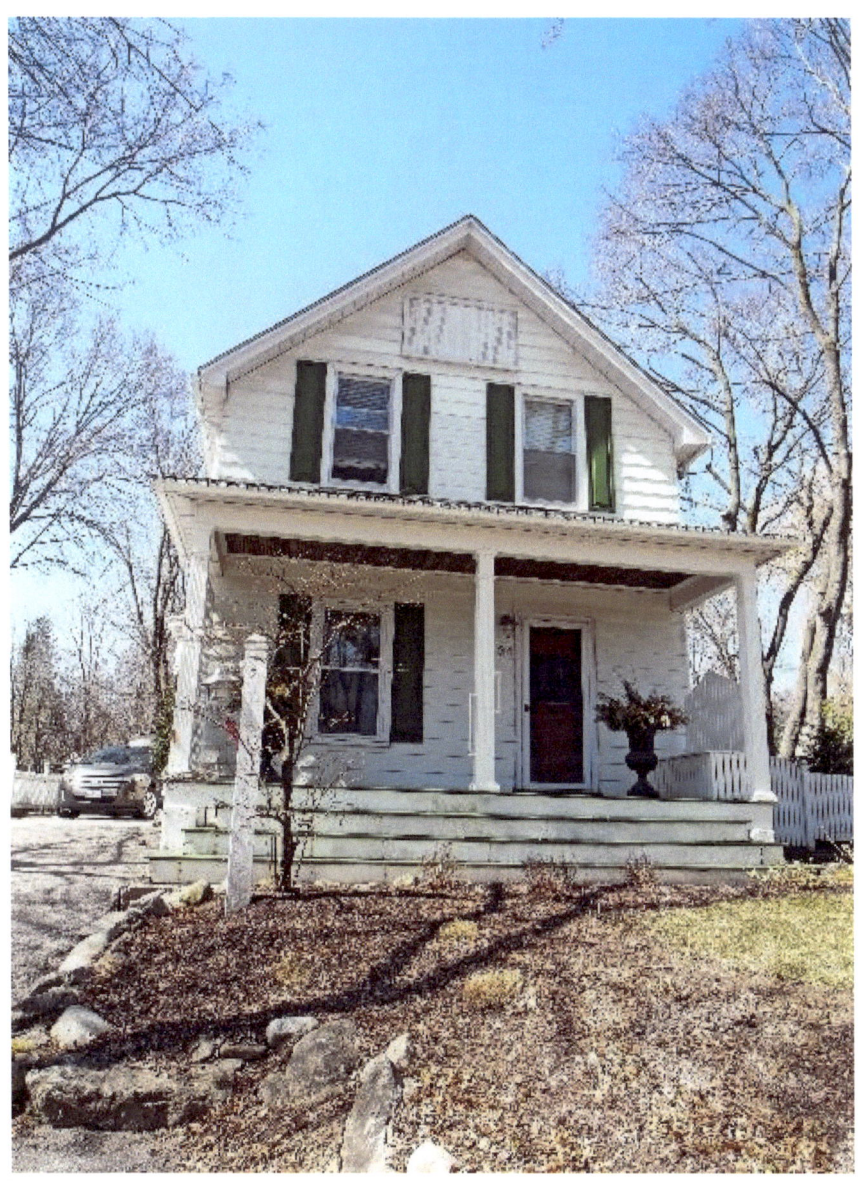

34 Lorne Street - Norman Davidson House – c. 1910 - This end gable Victorian frame house was built for Norman Davidson, who operated a barber shop on the main street. He and his wife Charlotte raised five children here.

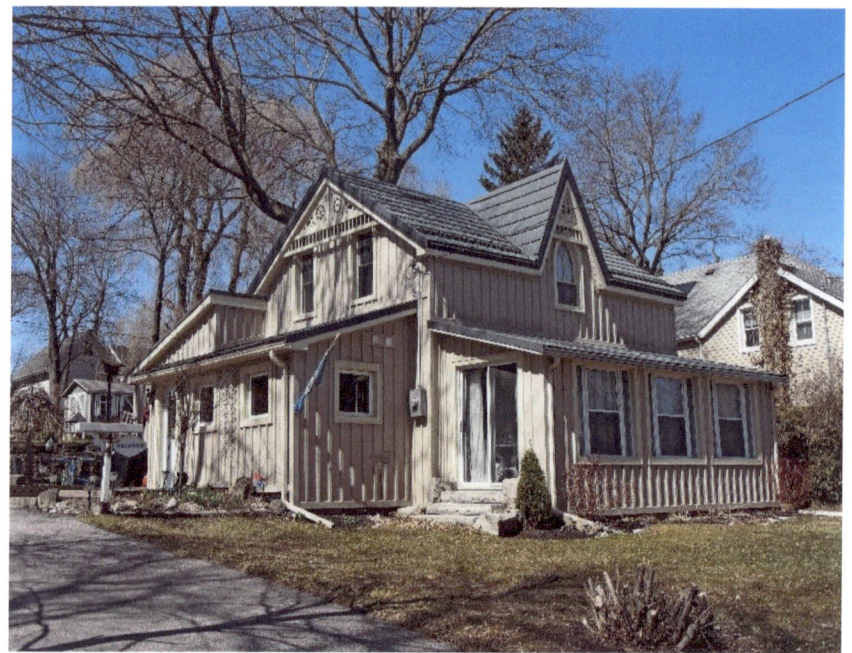

44 Lorne Street - Thomas Birkhead House – c. 1880s - This frame Ontario Cottage with centre gable and Gothic window was built to house mill workers.

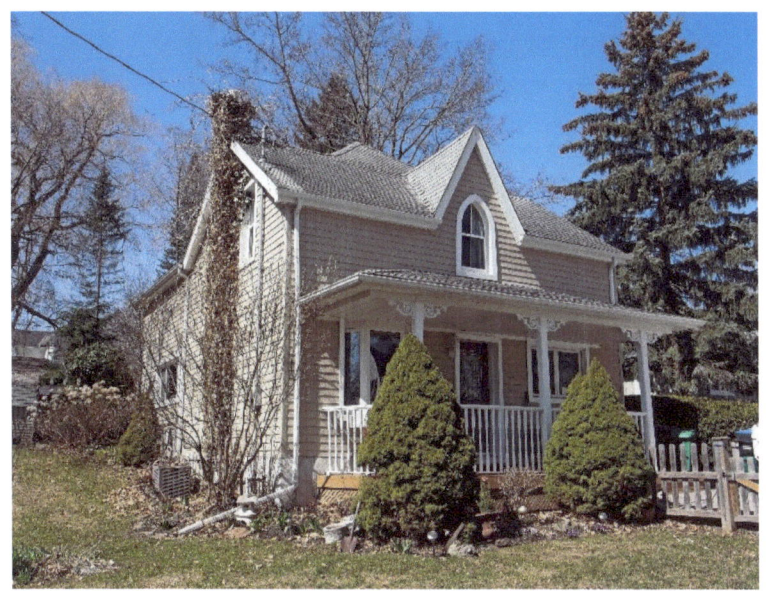

50 Lorne Street - McGregor House – mid 1880s - This 1½ storey frame Ontario Cottage with its centre entry, front verandah, steep front gable and simple Gothic window was built to house mill workers. It was built in the Carpenter's Gothic style.

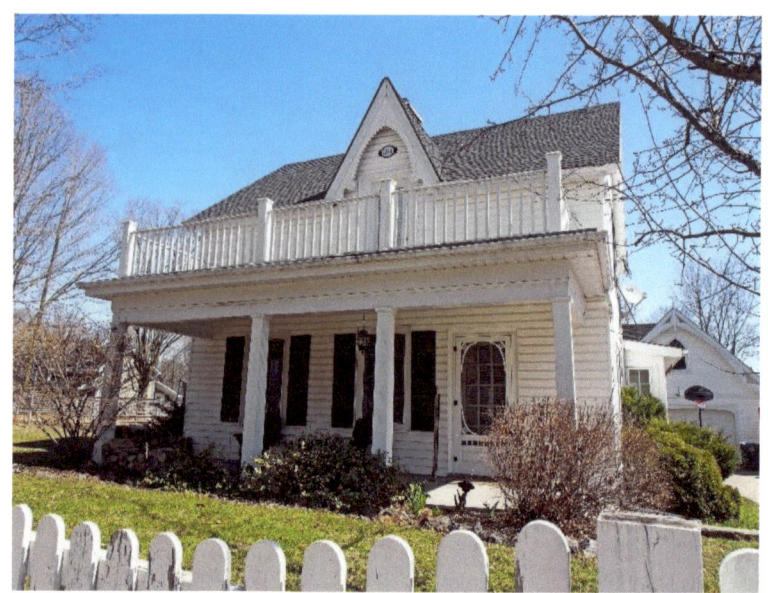

57 Lorne Street - David Graham House – c. 1864 - This large 1½ storey frame house has evolved from David Graham's 1864 Ontario Cottage home.

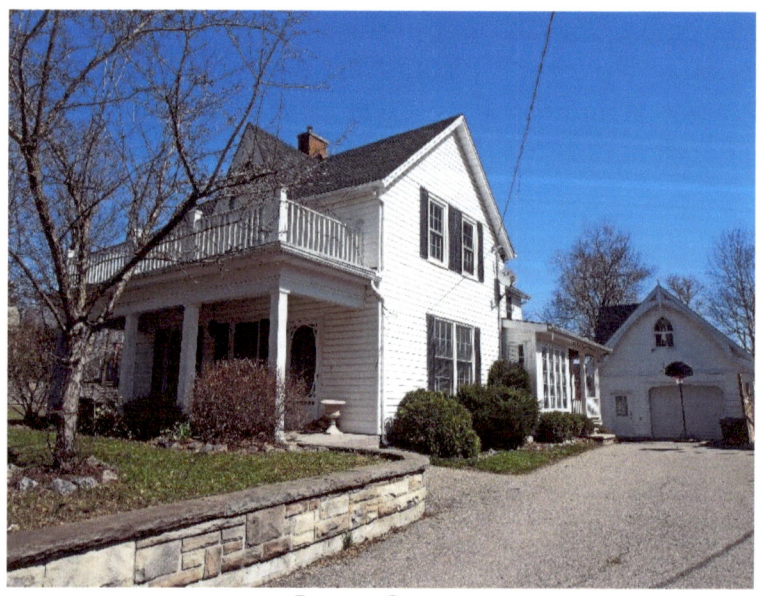

Lorne Street

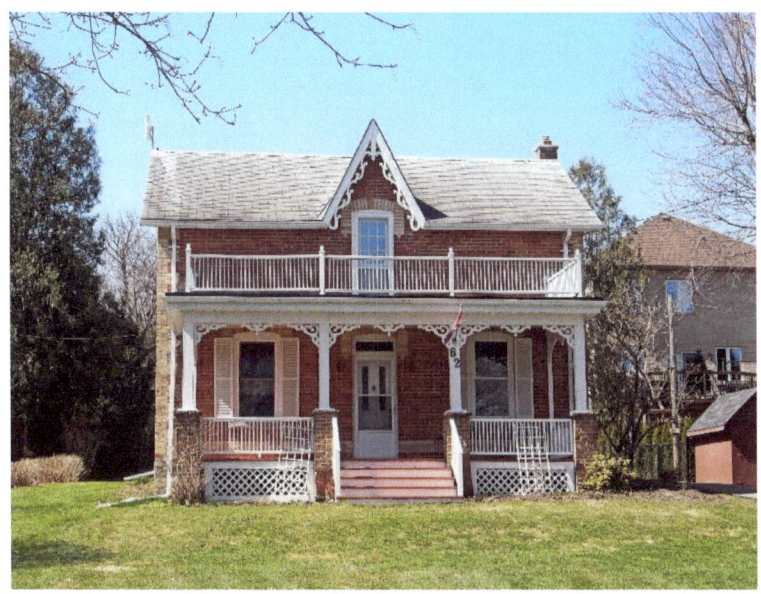

62 Lorne Street - Victorian Gothic House – c. 1895 - This 1½ storey home shares the same Gothic style as many of the homes on Lorne Street except for the exterior, which is veneered in red brick with yellow brick detailing. It was likely built by John Armstrong. Note the centre gable with fretwork trim, center entry and decorated verandah.

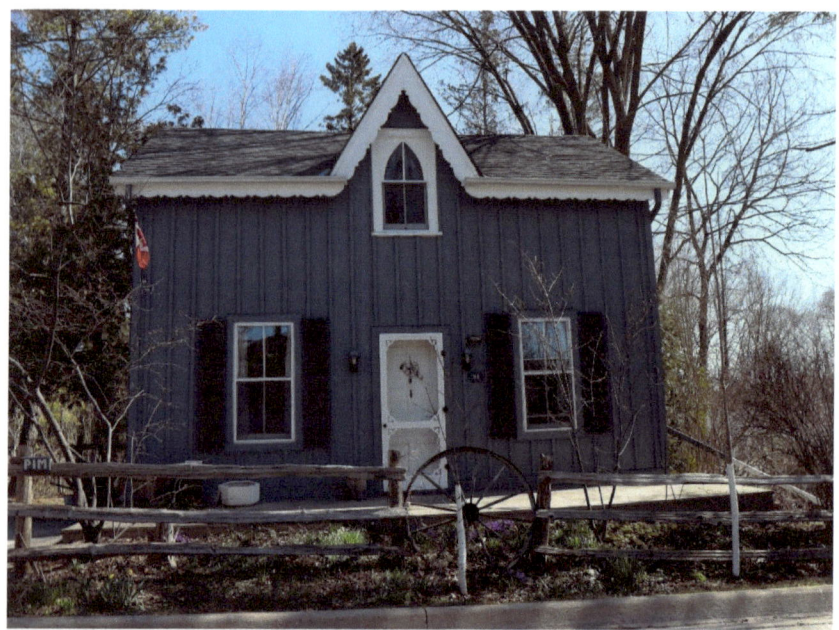

93 Lorne Street - Graham-Wilson-Pim House - late 1870s - This 1½ storey, board and batten Ontario cottage was built by mill owner David Graham to house mill workers. In 1909 it was purchased by Jesse Wilson and his wife Maggie. Living here for close to 60 years, they raised eight children, kept cows and chickens, grew vegetables and maintained fruit trees.

270 Macdonald Street

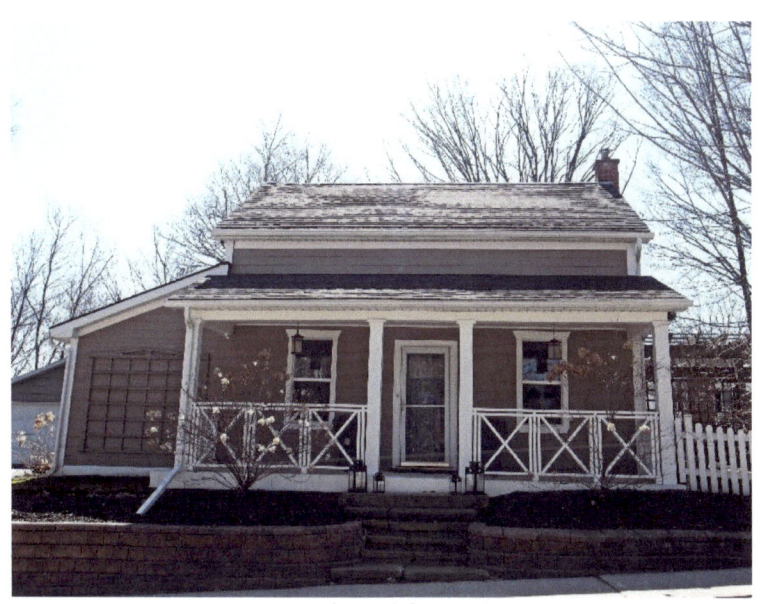

Macdonald Street

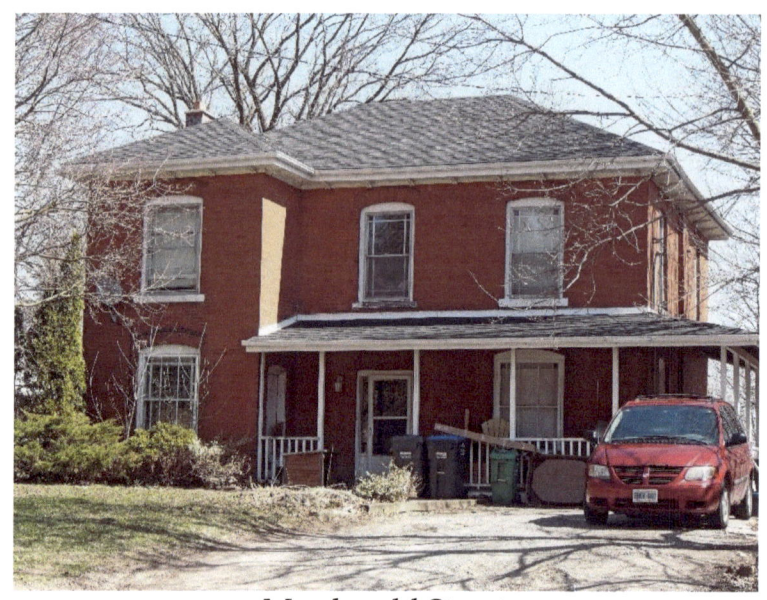

Macdonald Street

Building Styles

Edwardian, 1900-1930 – This style bridges the ornate and elaborate styles of the Victorian era and the simplified styles of the 20th century. Balanced facades, simple roof lines, dormer windows, large front porches, and smooth brick surfaces are its characteristics. Example: 20 Lorne Street, Inglewood, Page 59	
Gothic Revival, 1830-1890 – These decorative buildings have sharply-pitched gables with highly detailed verge boards, pointed-arch window openings, and dichromatic brickwork. It is a common style in Ontario. Example: Bush Street, Belfountain, Page 9	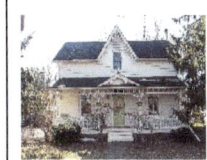
A **log cabin**, built from logs, was usually one- or 1½-storeys constructed with round rather than hewn, or hand-worked, logs, and erected quickly for frontier shelter. Log cabins were built from logs laid horizontally and interlocked on the ends with notches. The cabin was situated to provide sunlight and drainage so the pioneers could cope better with the rigors of frontier life. The pioneers chose old-growth trees that were straight and had few knots and did not need to be hewn to fit well together. Careful notching minimized the size of the gap between the logs and reduced the amount of chinking with sticks and rocks or daubing with mud to fill the gap. The length of one log was the length of one wall. Example: Belfountain, Page 31	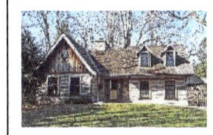

Neo-colonial (also Colonial Revival, Georgian Revival or Neo-Georgian) architecture seeks to revive elements of architectural style of American colonial architecture of the period around the Revolutionary War which drew strongly from Georgian architecture of Great Britain. Architecture from the 18th and early 19th centuries in Ontario includes a wide assortment of detailing and ornament applied to a design centered around the fireplace and the source of water. Structures are typically two stories, have a symmetrical front facade with elaborate front doorways, often with decorative crown pediments, fanlights, and sidelights, symmetrical windows flanking the front entrance, often in pairs or threes, and columned porches. Example: 15629 McLaughlin Road, Inglewood, Page 48	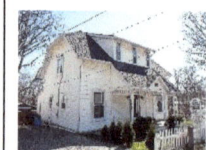
Ontario Cottage - one or one-and-a-half story buildings with a cottage or hip roof. The cottage roof is an equal hip roof where each hip extends to a point in the center of the roof. The hip roof has a long hip in the center. The Ontario Cottage is the vernacular design of the Regency Cottage which generally has a more ornate doorway and a partial or full verandah surrounding it. The roof can have a dormer, a belvedere, and generally two chimneys. Example: 15641 McLaughlin Road, Inglewood, Page 45	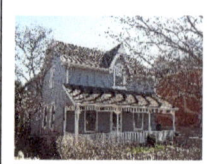

Victorian - In Ontario, a Victorian style building can be seen as any building built between 1840 and 1900 that doesn't fit into any of the other categories. It encompasses a large group of buildings constructed in brick, stone, and timber, using an eclectic mixture of Classical and Gothic motifs.
Example: 34 Lorne Street, Inglewood, Page 61

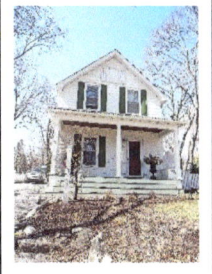

Other Books by Barbara Raue

Coins of Gold
Arrows, Indians and Love
The Life and Times of Barbara
The Cromwell Family Book
Laura Secord Discovered
Daddy Where Are You?

Montana Series
Book 1: Montana Dream
Book 2: Life on the Montana Frontier
Book 3: Montana to Boston and Back
Book 4: Montana Sons Go to War
Book 5: Montana Sons Return from War

© 2019 by Barbara Raue - All the photos in this book have been taken with my cameras. I own the rights to them.

www.ingramcontent.com/pod-product-compliance
Lightning Source LLC
Chambersburg PA
CBHW041104180526
45172CB00001B/106